HIDDEN
HISTORY
of
LORAIN
COUNTY

HIDDEN
HISTORY
of
LORAIN
COUNTY

Kelly Boyer Sagert

THE
History
PRESS

Published by The History Press
Charleston, SC
www.historypress.net

First published 2018

Manufactured in the United States

ISBN 9781625858580

Library of Congress Control Number: 2018940073

This book is dedicated with love and appreciation to my two incredible sons, Ryan and Adam, for all that you are and all that you are becoming. A special thank-you goes out to Anna Pohlod (the best intern in the whole wide world), Tracy Isenberg (a wonderful photographer) and Alyssa Phillips (the Microsoft Word genius).

CONTENTS

ACKNOWLEDGEMENTS

Iam so grateful for all the help I've received while writing this book, and I want to offer a heartfelt thank-you to everyone who shared their time, energy, passion and knowledge. I hope that I don't miss anyone!

Thank you to the Lorain County Historical Society, including Eric Greenly and William Bird; the Lorain Historical Society, including Barbara Piscopo, Kaitlyn Donaldson and Beverly Muzilla; and the Oberlin Heritage Center, including Liz Schultz and Maren McKee. I greatly appreciate your willingness to assist in any way that I asked.

I am grateful to all the museums, historical societies, cities, villages, towns and townships that provide information online, and I also appreciate the willing assistance of Jeff Sigsworth, Dan Brady, Matt Nahorn, Loraine Ritchey, Diane Wargo Medina, Hilaire Tavenner, Al Leiby, Deborah Wagner, Bruce Weigl, the Reverend Gerald Evans, Ralph Hayes, Alan Willoughby, Doris Wildenheim and Matthew Weisman.

Lorain County is filled with amazing history, and I wish there was room to share even more of its secrets and stories within these pages. Errors and omissions are my own.

Thank you!

INTRODUCTION

It is scarcely more than a hundred years since the first white settlers came within its borders. It is difficult for the present generation to imagine the conditions which surrounded the first settlers. Then a dense, almost impenetrable forest of trees of immense size covered every acre of this territory. The heroism of the families who plodded their way thither from New England, some on foot, some on horseback, and others in slowly moving carts, occupying more days in the journey than it takes hours now, is worthy of all praise. The rapid clearing of homesteads, and establishment of educational and religious institutions, scarcely find a parallel anywhere else in history.

—A Standard History of Lorain County, Ohio: An Authentic Narrative of the Past, with Particular Attention to the Modern Era in the Commercial, Industrial, Civil and Social Development. A Chronicle of the People, with Family Lineage and Memoirs, *edited by G. Frederick Wright, 1916*

SETTLING OF LORAIN COUNTY

The men, woman and children who left New England behind to settle what is now Lorain County needed to say good-bye to friends and family and their beloved communities, often for the very last time. They left behind all that was familiar, all that was comfortable, to take enormous risks and

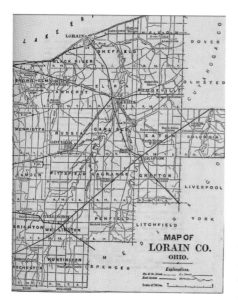

This map of Lorain County was published in *A Standard History of Lorain County, Ohio* in 1916. *Public domain.*

make enormous sacrifices. They traveled through dangerous woods, sometimes on foot, carrying with them what they needed to live. They were tough, smart and resourceful. They were survivors who didn't give up, even when the odds were stacked against them, people who were willing to risk it all to make new lives for themselves and their families.

The fertile land that was their destination had been in fierce demand by multiple nations and tribes in the decades leading up to the Revolutionary War. The French claimed the land because they'd explored it and, to some degree, occupied it, but that claim discounted the fact that Native Americans had long lived in this land, which was blessed with rich soil, lakes and rivers teeming with fish; skies containing countless species of birds; and forests full of wildlife. And when England collaborated with the Six Nations, Native Americans otherwise known as the Iroquois Confederacy, France could no longer maintain its claim of ownership.

Then, in the years leading up to the Revolutionary War, England found itself challenged by British settlers who wanted the American colonies to become an independent nation, a challenge that was ultimately successful.

After the war, the State of Connecticut, among others, held claims to land in what is now Ohio. Connecticut ceded most of its claims to modern-day Ohio to the federal government so the Northwest Territory could be created but kept a northern portion, including land along Lake Erie; this is what came to be known as the Connecticut Western Reserve.

The Western Reserve was then divided into two parts, with the western portion (the Sufferers' Land or the Fire Lands) being given to people who had lost their property during the war. The eastern part was sold to the Connecticut Land Company in 1795 for $1.2 million, and General Moses Cleaveland was sent to survey the region and create townships of twenty-five square miles each. One early township was named Cleaveland, but

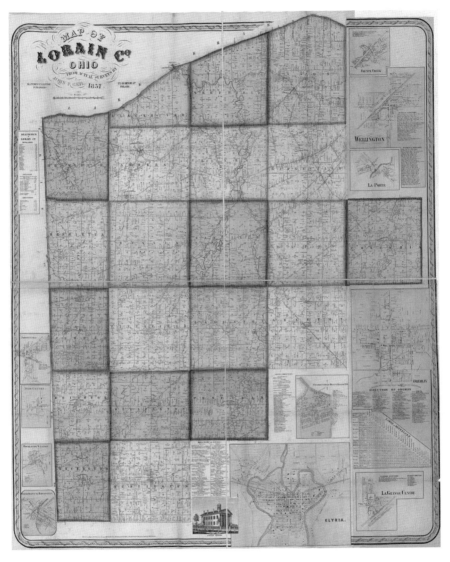

Here is an 1857 map of Lorain County based on "actual surveys." *Library of Congress.*

when a mapmaker misspelled the town's name in the 1820s, it became known as Cleveland.

Many groups of New Englanders—mostly from Massachusetts or Connecticut—were intrigued by the notion of starting new lives in these townships. On September 5, 1795, about three dozen men purchased property, either for themselves or to resell. The man who purchased the

General Moses Cleaveland was sent to survey the Connecticut Western Reserve and create townships of 25 square miles each. He bought a parcel for $32,600. *Public domain.*

most, paying $168,000, was Oliver Phelps; he also co-purchased another $80,000 worth of land with Gideon Granger Jr. Moses Cleaveland bought a parcel worth $32,600.

But because the initial seller of the plots of land (the Connecticut Land Company) was a commercial entity, not a governmental one, settlers were not given any military or legal protection. By 1820, though, an estimated 1,694 brave souls had nevertheless settled in modern-day Lorain County.

Early on, the estimated size of the Western Reserve (believed to be at least 4 million acres) was found to be incorrect, in part because of the way that Lake Erie sometimes dipped farther south into the land than anticipated. The real size was less than 3.4 million acres.

14

Many complications arose as this new land began to be settled, but in 1807, the first colonists from Connecticut settled in today's Lorain County, in what is now called Columbia Township (officially a township in 1809). And although it might be expected that the first settlers chose to build along Lake Erie, that township is actually located in the southern part of Lorain County.

The northern portion of Lorain County contains multiple cities today, including Amherst, Avon, Avon Lake, the county seat of Elyria, Lorain, North Ridgeville, Sheffield Lake and the eastern portion of Vermilion. It also contains the village of Sheffield and numerous townships, including Brownhelm Township. Because there is no hard and fast line between northern and southern Lorain County—geographically, this would divide several townships in half—for the purposes of this book, the rest of the county will be considered the southern portion, which is covered in chapter 2.

Forgotten Founders and Leaders, Northern Lorain County

L orain County is so rich in history that it isn't possible to provide even a short summary of all the highlights in one book. Even when limiting the choice of historical stories to spotlight those more hidden, it still can't, regretfully, all be included. So, this chapter contains overviews of the founding of Amherst, Avon, Brownhelm Township, Elyria and North Ridgeville, along with mini-biographies of people with a connection to these cities or townships. An overview of the founding of Lorain is contained in chapter 7, where the city's literary connections are explored.

AMHERST

The settlement that became Amherst was initially part of the Black River Township in Huron County before Lorain County was created. Briefly known by other names, including Corners, Amherst Corners and Plato, it officially became a village in 1836. The original village name was Amherstville; it was changed to North Amherst and then simply became Amherst in 1909.

A case could be made that Josiah Harris established Amherst around 1818—or Jacob Shupe did in 1811. Here's the case you could make for Harris. He left Becket, Berkshire County, Massachusetts, and settled near a spring located in today's Amherst around 1818, near modern-day South Main Street, and he built a tavern, which encouraged others to travel to the

area. Harris also started a brickyard so additional structures could be built, and he planned the area to have a central space for the community, similar to what he knew from Massachusetts.

In 1821, Harris was elected justice of the peace, and he held that position for thirty-six years. He served in the House of the General Assembly of Ohio, then as a state senator. During those years, some people tried to rescind the charter of Oberlin College, largely because of the school's abolitionist stance, and Harris fought hard to keep the charter.

When enough settlers arrived to justify a post office, Harris also served as postmaster of North Amherst for more than forty years. He was elected Lorain County's first sheriff and an associate judge. He donated land for Amherst Town Hall and for the Union School House, along with the initial buildings for these endeavors.

According to *The Early History of Lorain County: Historical Address*, "He was the object of universal respect by the inhabitants of the town of his adoption. Through the beneficence of his counsel, parties litigated often left his court with their cause amicably settled, with all irritation removed, and personal good feeling restored." Josiah Harris died at the age of eighty-four in 1868 and is buried in Amherst's Cleveland Street Cemetery.

So, the case for considering Harris as the founder of Amherst is solid, because he settled the area that is now the center of Amherst. But if you head about one mile north of the original village, then pioneer Jacob Shupe enters the picture. He left Pennsylvania and arrived near modern-day Amherst in 1811, three years before Harris temporarily arrived in 1814 to choose where he planned to settle and seven years before Harris began establishing a town. Shupe came with his wife and children.

Shupe constructed his own sawmill, one described by Amherst historian Matt Nahorn (who lives in the Shupe Homestead and firmly believes that, although Harris was an important *early* founder, Shupe was the *actual* founder of today's Amherst) as an "early, up-and-down sash-style, undershot waterwheel powered sawmill, powered off Beaver Creek. He dug a mill race across the valley of the Creek's floodplain to direct the water power for maximum efficiency." By 1813, Shupe had expanded this into a gristmill. A few years later, he also started the township's first whiskey distillery.

When Harris began clearing the woods about one and a half miles from where Shupe had settled, Shupe headed over and introduced himself to Harris and a hired carpenter named Ralph Lyons. He also brought them some of the fruits of his distillery, and the men celebrated the Fourth of July

This home belonged to Jacob Shupe, who started the Beaver Creek Settlement, freely spending his own money to do so. *Courtesy of the New Indian Ridge Museum at the 1811 Historic Shupe Homestead.*

together. Although Shupe's settlement was later incorporated into Amherst, it was not part of the original village plat laid out by Harris.

Shupe freely spent his money to improve the area. In 1832, while attempting to extend one of his mills, timber fell on him. His injuries were severe and resulted in his death, but his wife, Catherine, lived to be ninety years old.

Today, these men's names live on in Amherst schools: Josiah Harris Elementary School and Shupe Elementary School.

Amherst quickly became well known for its sandstone. By the latter part of the nineteenth century, Amherst even began being called the Sandstone Center of the World because of the numerous sandstone quarries in operation. Therefore, many early buildings in the area were constructed of this material.

Amherst was also the birthplace of a man whose name is strongly associated with educational programs intended to help people advance in the workplace. Although his last name is still used today in the name of the educational institution he co-founded, the story of his life and his association with Amherst has largely been forgotten.

Henry Dwight Stratton

Have you ever seen or heard a commercial about Bryant & Stratton College? The list of graduates is both long and impressive, including multiple governors: Harold J. Arthur (Vermont), J. Millard Tawes (Maryland), Benjamin S.

Paulen (Kansas), George H. Prouty (Vermont) and James Hamilton Peabody (Colorado). Senators include William J. Grattan and Douglas Hudson, both of New York, plus Marcus A. Coolidge (Massachusetts) and John W. Harreld (Oklahoma). Additional Bryant & Stratton students included Henry Ford, John D. Rockefeller, Joseph Seagram of distillery fame, Brigadier General Charles Woodruff and many more.

And one of the co-founders of this college—Henry Dwight Stratton—was born and raised in Amherst, Ohio. Born on August 24, 1824, he attended Amherst public schools before taking classes at nearby Oberlin College. On May 29, 1854, he married Parmella Bryant in Cleveland. The ceremony was a double one, as his sister married his new brother-in-law Henry Beadman Bryant, with Oberlin College president Dr. Charles Finney conducting the ceremony; Finney also was a Protestant minister.

Then, Stratton, Bryant and another brother-in-law (Henry's brother, John Collins Bryant) graduated from Folsom Business College of Cleveland. This school was founded in 1848, but only two students enrolled in the first term: One identified as "Mr. Bryant" and Stratton. Fortunately, as northeast Ohio's industrial base grew, employers needed skilled workers, and the school attracted increasing numbers of students.

The two Bryants and Stratton purchased the school from Folsom in 1854 and renamed it the Bryant and Stratton National Business College, with a goal to provide practical education for the workplace. The men also created business schools that they named Bryant & Stratton & Co.'s International Commercial Colleges.

In this era, people often relied upon hard-to-secure apprenticeships to learn a trade, so classroom and lab experience was a much-needed innovation. In 1855, the college started a ladies' department. In 1858, the school began offering what the website calls "the only completely practical bookkeeping course in the world," using mock banks, stores and insurance companies to teach students. In 1860, the founders hired Amos Dean to write business law books for students; Dean had founded the first independent law school in the country.

By 1864, approximately fifty of these schools existed, placed in major cities in the United States. Tuition was forty dollars for the program, and each of the schools used the same textbooks, ones usually written by Bryant and Stratton. The programs lasted three to four months, and students could switch from one of the schools to another if need be, and graduates could return for free refresher classes. In 1865, the school encouraged returning Civil War soldiers to attend classes, saying that "business is the battle of peace."

Stratton died on February 20, 1867, in New York City. After his death, the chain school concept faded away, although some colleges remained open—and still do today, some operating under the Bryant & Stratton name. Innovations continued at these schools, and here are just three examples. In 1868, the first commercially available typewriter was invented, so the school hired a renowned stenographer and began teaching students how to transcribe shorthand on the typewriter shortly after the invention debuted. In 1889, this became one of the earliest colleges to offer correspondence courses, and in 1910, the school was already offering technology courses using electricity.

AVON

The area that is now Lorain County was once fiercely fought over. For example, as the American Revolution was ending in 1783, a history of Avon noted that "the British and the Iroquois organized a general Indian confederation to defend the Ohio River frontier against the Americans." In the 1805 Treaty of Fort Industry, however, the Native Americans ceded territory west of the Cuyahoga River and south of Lake Erie, which includes today's Avon, Ohio. Choosing to travel to this territory to settle it, though, was still fraught with danger, especially during the early post-treaty years.

In 1807, Pierpont Edwards was awarded what is modern-day Avon, along with three of the Bass Islands, located nearby in Lake Erie. Edwards was a distinguished soldier, judge and politician. Born on April 8, 1750, in Northampton, Massachusetts, he was the eleventh and last child of Reverend Jonathan Edwards, the famed Puritan preacher, philosopher and author perhaps best known for the fiery sermon titled "Sinners in the Hands of an Angry God."

Edwards was educated at the College of New Jersey (now Princeton University) and graduated in 1768. He opened a private law practice in New Haven, Connecticut in 1771, which was soon disrupted by his service in the Revolutionary War. In 1777, he was elected to the Connecticut House of Representatives and also served in 1784–85 and 1787–90. He was a delegate to the Continental Congress in 1787–88, part of the ratification committee for the Constitution; the following two years, Edwards served in the state house of representatives as Speaker of the House before returning to private law practice, which he did until 1806.

When a position was vacated in the U.S. District Court (Connecticut), Thomas Jefferson nominated Edwards on February 21, 1806, to fill that position. He was confirmed three days later and served in that position for twenty years, until his death on April 5, 1826. In that period, in 1818, he participated in the convention that created Connecticut's constitution. Although nothing in Lorain County is named after him, Pierpont Township in Ohio's Ashtabula County is named in his honor.

His son Henry had a highly successful political career, and his daughter Henrietta married Eli Whitney, inventor of the cotton gin. Aaron Burr, who served as Thomas Jefferson's vice president during his first term, was Edwards's nephew. Another nephew, Timothy Dwight IV, was Yale College's eighth president.

Although Edwards was awarded the land that became Avon, he did not settle the area. Noah Davis built a log cabin in today's Avon in 1812 but didn't remain long. To quote *A Standard History of Lorain County, Ohio*,

> *The first settler in Avon on the lake shore is said to have been one Noah Davis. He came in 1812, did not remain long, went away and never returned. He was here two years before any one is known to have settled on the ridge and appears to have been the Moses Cleaveland of Avon. One wonders what became of him. Is there any way of finding out his origin or his destiny? Like the man in the iron mask, the first settler on the lake shore in Avon, we fear will ever remain a mystery....He erected the first log house, but where it was located, or who composed his family, we have been unable to ascertain.*

The first permanent white settlers arrived in modern-day Avon in September 1814, led by Wilbur Cahoon from Montgomery County, New York. The other two men were Lewis Austin and Nicholas Young. They were intrigued by reports from Cahoon's half-brother Joseph, who had settled nearby in today's Bay Village in Cuyahoga County. Originally, modern-day Avon was considered part of Cuyahoga County (since Lorain County hadn't yet been created) and was listed as Township Number 7. In 1818, the township was called Xeuma (or Xenia)—Greek for "generosity or hospitality"—and then Troy Township. When Lorain County was established in 1824, the name changed again: Avon Township after Avon, New York. The post office was created a year later.

According to Cleveland.com, Cahoon was a "42-year-old carpenter owning 100 acres of land in Salisbury, NY. He had a wife, seven children,

and a[n] adventurous spirit." By the time Cahoon and his family headed to Ohio, his family had already been in America for more than 150 years. His ancestor William immigrated from Scotland, probably before 1651, settling in Rhode Island. He was a brick maker, and in 1660, he and sixteen others purchased Block Island, Rhode Island. William fought in the Indian Wars of 1675 but died in battle.

A man descended from William, a direct ancestor of Wilbur's, was named Ebenezer. He was a carpenter in Rhode Island and fought for the British as a lieutenant in the French and Indian War from 1754 to 1763. Wilbur Cahoon's father also had the fighting spirit and participated in the Revolutionary War for the colonies. Wilbur Cahoon was born to Reynolds and Mary Cahoon on December 27, 1772, in Hancock, Massachusetts. He married Priscilla Sweet from Rhode Island in 1795, and the couple settled in Salisbury, New York. The seven children born in New York were named Susan, Jesse, Wilbur, Ora, Orra, Huldah and Melissa.

When land was offered for sale in the Western Reserve, Cahoon accepted the challenge inherent in heading to the wilderness, even though the War of 1812 was being fought in the Great Lakes, among other locations. Another potential danger was that Native Americans were being encouraged by the British to attack settlers. Cahoon nevertheless traded his one hundred acres in Montgomery County, New York to the Connecticut Land Company in exchange for eight hundred acres in today's Avon. He also received $100 but was required to build the first saw and gristmills.

The family traveled 425 miles to their new home, arriving in September 1814 and settling down along French Creek as Avon's first permanent white settlers. Just a few short weeks later, on December 1, a new baby arrived: Leonard.

The land was covered by dense forests and filled with underbrush that made it easy to get lost, even a short distance from home. Trees included black walnut and oak, elm and ash, maple, chestnut and butternut, hickory and sycamore, beech, cottonwood, birch and black cherry. The pioneers brought as much food as they could from Connecticut and then tried to plant crops as quickly as possible. They built the mills that were required as part of their land purchase along with cabins.

The mills were so successful that farmers came all the way from today's Elyria and Lorain to the west and Clague Road to the east to use their services. Life couldn't have been easy, however. The year 1816 was described as one without a summer after the 1815 eruption of Mount Tambora in

today's Indonesia wreaked havoc with the weather. An economic crash in 1819 was followed by a depression that left many men jobless.

With the help of other settlers, though, the Cahoons created schools and churches. The Cahoons built a large, twelve-room, Greek Revival–style home that still stands today. This style of architecture was popular in the United States because the Greeks were fighting for freedom, which appealed to them; plus, the British Georgian and Federal styles were much less popular in that era.

Cahoon purchased additional land, initially 160 acres. Later, Cahoon added another 150 acres, making his total investment for the property where his house was built equal $550. Cahoon started building his home in 1825 but died of a stroke on September 27, 1826. It was described this way: "Suddenly and swiftly came the pale messenger; while in full health he was stricken down with apoplexy and in one brief hour had passed on." His wife survived him by twenty-nine years, and his descendants continued to live in Avon.

Descendants of Wilbur Cahoon founded the French Creek Cheese Factory in March 1875. At its peak, the milk of two hundred cows was needed to supply the cheese factory with its key ingredient. The arrival of the railroad in 1882 meant that milk could be quickly shipped to other markets, and this particular cheese factory couldn't keep up with the competition.

The last direct descendant living in Avon was Roy Cahoon, born in 1893. He married Grace Peak, and they farmed seventy-one acres. He served in World War I. The Cahoon home on Stoney Ridge Road was listed in the National Register of Historic Places in 1978. It is a private home, not open for public tours, although the owners sometimes provide tours for schoolchildren and are a driving force behind researching the Cahoon history.

BROWNHELM TOWNSHIP

Colonel Henry Brown of Stockbridge, Massachusetts, traveled to Ohio in 1816 to purchase land. He then contracted with the Connecticut Land Company to buy Lot 6 in Range 19. In the fall, he returned to what became Brownhelm Township with several other people who helped him to build a log cabin. One of those who accompanied Brown was Peter P. Pease, who became Oberlin's first settler. Another was Charles Whittlesey.

Whittlesey, who was born on October 4, 1808, would have been a young boy when traveling to the wilderness of Ohio, and he became a fascinating

man. After he graduated from West Point in 1831 and served in the Black Hawk War of 1832 (a brief war against the Native American Sauk tribe, led by Black Hawk), he served as the editor of the *Cleveland Herald* in 1836 and 1837 and worked as an attorney. In 1837, he was selected as an assistant geologist for Ohio and discovered multiple Native American earthworks. In 1838, he participated in Ohio's first geological study.

When Abraham Lincoln was elected president, Whittlesey served as an escort, guarding Lincoln as he traveled from Illinois to Washington, D.C. Then, when the Civil War broke out, Whittlesey immediately enlisted and was named the assistant quartermaster general for troops in Ohio. He became Ohio's chief engineer, then the commanding colonel for the Twentieth Ohio Infantry. He participated in the Battles of Fort Donelson and Shiloh. After resigning in April 1862 because of health issues, Whittlesey returned to his geological work. In 1867, he helped to found the Western Reserve Historical Society and served as president until his death on October 18, 1886. He was a prolific writer, as well, writing two hundred or so books and articles; his topics tended to be about geology or Ohio's history.

Returning to Brownhelm Township History

On July 4, 1817, three families arrived at this land: those of Stephen James, Sylvester Barnum and Levi Shepard. Several additional families followed, including those of Benjamin Bacon (his home, the first wooden frame one in the town, is available for tours through the Lorain County Metroparks), Solomon Whittlesey, Ebenezer Scott, Alva Curtis and several others. In the summer of 1819, Grandison Fairchild constructed the township's first brick home.

Until October 1818, this area was considered part of Black River. Once it became its own township, residents gave Colonel Brown the honor of naming it, but some didn't approve of his choice because *helm* was Saxon for "home," which meant that the township name translated to Brown's Home. A petition was signed to rename the town Freedom, but it didn't take effect.

In less than four short decades after Colonel Brown arrived in Ohio, this small township made a radical choice in leadership.

John Mercer Langston

Although this township is not especially large, even today (according to the 2000 census, 7,782 people lived there), significant national history happened there on April 2, 1855, when John Mercer Langston was elected town clerk. He was one of the very first black men in the United States to be elected to a public office and the first in Ohio. He went on to become a U.S. congressman. He had already become Ohio's first black lawyer in 1854.

Langston was born in Louisa County, Virginia, on December 14, 1829, to a white slaveholder father and an emancipated slave mother. They both died when he was fairly young, leaving him a significant inheritance. Moving to Chillicothe, Ohio, he stayed with a family friend before moving to Cincinnati, where he became increasingly aware of racial inequality. He then moved to Oberlin, where he earned an undergraduate degree in 1849.

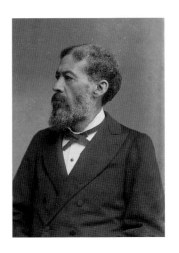

John Mercer Langston was one of the first black man in the United States to be elected to a public office, and he went on to become a U.S. congressman. *Library of Congress.*

Oberlin College was the first college to admit people of all races and the first to admit women as students. Women were permitted to study at the institution from its inception in 1833 and could start earning bachelor's degrees in 1837. Black students began being admitted in 1835.

Langston continued his education at Oberlin College, earning a master's degree in theology in 1853, but he could not gain admittance to law school. He therefore studied privately in Elyria. When he passed the bar exam in 1854, he became the first black attorney in Ohio. Langston opened a law firm in Brownhelm, where he was elected town clerk. He then returned to Oberlin in 1856 and is believed to have assisted runaway slaves to freedom through the Underground Railroad and was a driving force behind antislavery societies. When the Civil War erupted, he helped recruit troops for the Union cause and played a key role in building the first black regiment in the country: the Fifty-Fourth Massachusetts. This regiment was featured in the Academy Award–winning movie *Glory*, starring Denzel Washington, Matthew Broderick and Morgan Freeman, and was led by General Quincy Adams Gillmore of Lorain.

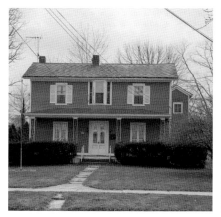

John Mercer Langston, one of the first elected black officials in the United States, lived here from 1856 to 1867, the only remaining residence with a connection to him. *Library of Congress.*

In 1864, Langston was a leader of the National Equal Rights League (NERL) along with Frederick Douglass and Henry Highland Garnet. They believed in and promoted full and immediate citizenship of all black Americans as compensation for service in the Revolutionary War and then the Civil War. They also promoted the rights of black men to vote. In 1865, they forwarded an idea considered so radical that it didn't become law until nearly a century later: integrated education, with the caveat that this should not cause discrimination against black educators. Some members of the group also favored political rights for women, while others feared that this emphasis might detract from the efforts to gain voting rights for black males in the South.

After the war, Langston served as an Oberlin councilman from 1865 to 1867, becoming a member of the town's board of education. He then moved away from Ohio, becoming involved in setting up a law department at Howard University in 1868. He served as acting president, but when he actually ran for the presidency in 1875, his name was eliminated from the ballot because of his race, even though Howard was a black institution.

President Ulysses S. Grant then appointed Langston to the board of health in the District of Columbia in 1875. In 1877, President Rutherford B. Hayes named him the U.S. minister to Haiti; he served in that capacity until 1885, when the Virginia Normal and Collegiate Institute named him its president. In 1888, Langston became the first black person to win a congressional election in Virginia when he was elected to the U.S. House of Representatives. He

served from September 23, 1890, to March 3, 1891. Sadly, this victory was contested for eighteen months. By the time his win was confirmed, he could serve for only six months and was unseated in the subsequent election.

Mercer died on November 15, 1897. A monument honoring him was sponsored by the Ohio Bicentennial Commission, the Longaberger Company, Brownhelm Historical Association and the Ohio Historical Society (now the Ohio History Connection) and is located at the former Brownhelm High School at 1940 North Ridge Road in Vermilion.

ELYRIA

Although a man named Mr. Beach technically arrived at modern-day Elyria first (in 1816), Heman Ely is considered the founder of the original township. In March 1817, he came from West Springfield, Massachusetts, to claim and develop 12,500 acres of land around the Black River falls. His father, Justin, purchased the land from the Connecticut Land Company.

About two months before he arrived, three men—said to have been carrying axes on their shoulders—walked from Massachusetts to Ely's acreage: Roderick Ashley, Edwin Bush and James Porter. They cleared forest land in anticipation of Ely's arrival, and one of them—Porter, identified as the Irishman of the group—remained and built houses; the other two eventually returned to New England.

Ely initially stayed in a tavern owned by Captain Moses Eldred located two miles east of modern-day Elyria (in Ridgeville). Eldred was from Rome, New York, and after serving in the War of 1812, he built a log tavern, which provided a place for other new settlers to stay.

Ely contracted to have a dam built in the Black River on the east portion, along with a gristmill, a sawmill and a log house for workers. In the fall of 1818, Ely traveled to his former town in Massachusetts on the *Walk-on-the-Water*, the first steamboat to use Lake Erie to go to Buffalo. On October 10, 1818, he married Celia Belden; the couple returned to Elyria, living in a log cabin while their home— a two-story structure sided by whitewood—was being built. The couple had two sons, Heman and Albert, before Celia died in 1827. (At least one source also lists a daughter, Mary; Ely went on to marry two more times.)

This home was the first permanent structure in the settlement. The second was the Beebe Tavern, constructed by Artemas Beebe, who came to

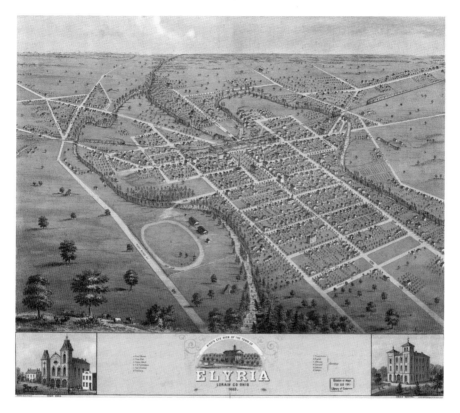

This 1868 map is a bird's-eye view of the county seat of Lorain County: the city of Elyria. *Library of Congress.*

the settlement in February 1817. Settlers socialized in this building, which also served as the area's news exchange and political center. Others who came in February 1817 included Ebenezer Lane; Luther Lane, a driver; Ann Snow, a cook; and Ned, a black child.

The town quickly grew, gaining a postal route in May 1818 (with Ely serving as postmaster). On October 20, 1819, Elyria officially became a township. Then, in 1822, part of the township became its own entity: Carlisle. Some people had wanted to name it Murraysville; others advocated Berlin.

Shortly after that, on December 26, 1822, the state legislature established Lorain County as an entity, and the question quickly arose about where to locate the county seat. People in three different townships—Black River (now called Lorain), Sheffield and Elyria—all wanted their locales to be chosen. Elyria's location was most central, which gave it an edge. Plus, Ely

promised to donate land, a temporary courthouse, a jail and $2,000 toward a permanent structure for a courthouse. Elyria was chosen.

On February 14, 1823, construction of the courthouse, a small, one-story frame building at the intersection of Main and Cheapside Streets, began. By May 24, 1824, the court was already in session, with Ely serving as judge. By 1846, Elyria boasted a population of 1,500, a mill, a newspaper office, two factories, ten stores and six churches. Now here's more about one of Elyria's earliest settlers.

Ebenezer Lane

Ebenezer Lane was a chief justice of the Ohio Supreme Court and one of the original settlers of Elyria. Lane was born on September 17, 1793, in Northampton, Massachusetts, to Captain Ebenezer and Marian Chandler Lane. He enrolled at Harvard University at the age of fourteen and graduated in 1811. After university, Lane moved to Lyme, Connecticut, to study law with his uncle, Judge Matthew Griswold. In 1814, at the age of twenty-one, he was admitted to the bar and began practicing law in Norwalk, Connecticut, moving to Windsor Hill a year later. On May 21, 1816, he became a notary public for Hartford County.

One of the original settlers of Elyria, Ebenezer Lane became a chief justice of the Ohio Supreme Court, where he made numerous decisions of significance. *Public domain.*

Lane earned his place in the history of Elyria in 1817, when he joined a western expedition led by his stepbrother Heman Ely. Before his departure, he wrote to his cousin Charles Griswold about the journey: "[W]hether I am right or wrong will be known only by the event; but I feel the strongest assurance of hope, that it will be much for my advantage." Lane, Ely and the rest of the party traveled to Ely's 12,500 acres of land in what is now Lorain County and established the town of Elyria in 1817. Finding little need for his services as a lawyer in the brand-new settlement, Lane bought 64 acres of land from Ely and began farming.

The two years Lane spent in Elyria were brief but formative. He left town in 1819, moving to Norwalk, Ohio, after he was appointed prosecuting

attorney of Huron County. Though short, Lane's time in Elyria showed him the advantages of living in Ohio. On April 22, 1820, he said in another letter to his cousin: "I am sensible something must be sacrificed, in exchanging New England for Ohio, yet I for my part feel more pleased with living here than there."

Lane continued to show his legal expertise and was admitted to practice before the U.S. Circuit Court in Columbus on January 8, 1822. On February 17, 1824, Lane was elected president judge of the Second Judicial Circuit by the Ohio General Assembly. On December 18, 1830, before the end of his seven-year term, the Ohio General Assembly elected Lane to the Supreme Court of Ohio. He then served as chief justice from 1840 to 1845.

During his service on the Supreme Court, Lane helped make many significant decisions that still influence the law today. In *Lessee of the City of Cincinnati v. the First Presbyterian Church*, Lane and the other justices ruled that town and city governments cannot file a lawsuit against another organization after the statute of limitations has expired. He and the other justices also ruled in *Parker Jeffries v. John Ankeny et al.* that people with a majority of white heritage can legally vote and benefit from the same privileges, political and social, as white citizens.

On February 16, 1845, Lane resigned as chief justice, but he was not yet finished with his work. He returned to his private law firm in Sandusky in Erie County (adjacent to Lorain County), which he shared with his colleague Walter Stone and his son William Lane. In 1850, he was awarded an honorary doctor of law degree. He also became the president of the Mad River and Lake Erie Railroad, the Columbus and Erie Railroad and the Junction Railroad. He moved to Chicago in November 1855 after he was elected counsel and resident director of the Central Railroad of Illinois. He also became a member of the New England Historical and Genealogical Society, the New York Historical Society, the Ohio Historical Society and the Chicago Historical Society.

Lane finally retired in 1859. He fulfilled his lifelong dream of traveling to Europe and moved back to Sandusky to pursue his personal academic studies. Lane died in his home on June 12, 1866, leaving a legacy as an original settler of Elyria and an influential lawyer who changed the history of an entire state. A fellow attorney, C.L. Latimer, said of Lane: "Ohio will never fully understand how much she is indebted to Judge Lane and those like him, who, before and with him, wrought at the foundation of our social security and general happiness and progress as a State."

NORTH RIDGEVILLE

As glaciers receded from the geography that is now Lorain County, numerous lake ridges were formed. Because of this, the county is filled with streets with names such as North Ridge Road, Middle Ridge Road and the like. Modern-day North Ridgeville was especially affected by the ridge-making properties of long-ago glaciers, with streets named Sugar Ridge Road, Butternut Ridge Road and Chestnut Ridge Roads in modern times. These ridges were attractive to settlers, as they naturally formed roads for travel and the sandy soil made them conducive to growing crops and building structures.

Perhaps because of this attractive landscape, North Ridgeville was the second township in Lorain County to be settled, after Columbia. The settlers came from Waterbury, Connecticut, just like those who settled Columbia. In 1809–10, David Beebe Sr., Oliver Terrell and Ichabod Terrell traded their Connecticut land for one fourth of what became North Ridgeville. On May 10, 1810, eighteen men arrived to settle the area, mostly from the Terrell and Beebe families. They included David Beebe and his sons (David Jr. and Loman), Joel Terrell and Lyman Root. In its earliest days, it was called Rootstown after early settlers with the surname of Root.

That group of settlers included three Terrells who originally came to Columbia Township in 1809 and then walked to Ridgeville, building a log cabin on what is now Bainbridge Road. The first woman, Mrs. Electa (Tillotson) Terrell, came in July 1810 with three children. Four of these early settlers fought in the Revolutionary War, while Oliver Terrell—then about eighty—also fought in the French and Indian War and made the entire trip to Ohio on horseback.

The first structure was made of small logs with an earthen floor and a roof made of bark. One of the first settlers, Ichabod Terrell, was married to Rhoda; it was noted that she survived a massacre in Wyoming and, upon her death, left ninety-one grandchildren and a large, unspecified number of great-grandchildren.

In 1813, the men of the settlement voted to incorporate the township and renamed it Ridgeville. It was noted that all fifteen of the eligible voters participated in the election. Three trustees were elected, along with a justice of the peace, a constable and a township clerk. They all had the last name Terrell or Beebe. Residents of the township joined the Ohio militia (Hoadley's Company), based in Columbia, during the War of 1812.

The name of the post office was changed to North Ridgeville in 1829 because there was another Ridgeville in the southern part of the state, and mail delivery often got mixed up. For a deeper yet more personal look at the early days of today's North Ridgeville, here is the story of Joel Terrell.

Joel Terrell

Picture a man who, in his early fifties, was willing to walk more than six hundred miles from Waterbury, Connecticut, to build his new home and business in the wilderness that became northeast Ohio. This man, while primarily a farmer, was also a prolific bee hunter, an early justice of the peace and a cobbler who repaired the other pioneers' shoes. Terrell was the driving force behind the town's first mill, and he opened and operated the Indian Tavern from his home, where he provided lodging and sold whiskey to the Native Americans in the region. It was astonishing how much physical work he did when past the age of fifty; he was known for amazing versatility and astute business planning.

Terrell led the first religious services in town—and he also started the town's first cemetery, originally called Terrell's Burying Ground. He donated half an acre for this purpose. This cemetery later became known as Ridgeville Center Cemetery and is located at the intersection of Center Ridge and Stoney Ridge Roads.

Joel Terrell was born in July 1757 in Connecticut. His parents were Captain Josiah Terrell Jr. and Eunice (Hoadley) Terrell. He had a brother named Elihu and a sister named Polly. As a young man, he fought in the Revolutionary War, first enlisting in the spring of 1775, serving for eight months as a private in Captain Peck's Connecticut Company. In this unit, he participated in the Siege of St. Johns and the Battle of Princeton. He then reenlisted in 1777 perhaps serving in a militia unit. Terrell married Eunice Emma Hodge (born on September 9, 1758) on December 30, 1778. The couple had two children: a son, Wyllys (February 17, 1780–April 13, 1830), and a daughter, Polly, born on May 5, 1785. Polly married a man with the last name of Worster and died in April 1805 shortly before she was to turn twenty.

Arriving in what is now North Ridgeville in May 1810, Terrell clearly had a different philosophy from the other pioneers who arrived with him. The others began clearing the land to build small cabins, something to protect them from freezing during the winter months. Terrell, instead, began

building an extra-large structure, intended as an inn; his brother, Elihu, among others, helped him. He selected a unique site west of center, at the juncture of Center Ridge and Stoney Ridge.

He then walked back to Connecticut in the fall and spent the winter there. He left for Ohio again late the following summer, after saying farewell to Connecticut friends and family members. This time, he brought his wife and son with him, arriving in September 1811. The men finished building the cabin that Terrell had started—and then he built another tiny cabin, one intended for himself and his wife.

He had already grown three acres of winter wheat in the fall of 1810, using borrowed oxen, and he made shoes from leather he'd brought back from Connecticut. His son, meanwhile, handled the daily operations of the inn. The inn was especially appreciated by Native Americans who were traveling between modern-day Cleveland and Sandusky, with entire families visiting the tavern. Visits from Native Americans ceased during the War of 1812 but picked up again afterward. Too old to sign up for the militia, Terrell extensively served in the War of 1812 as a guard for Ridgeville.

He died on March 22, 1825 and is buried in the Ridgeville Cemetery. He is one of eleven Revolutionary War veterans buried in Ridgeville Township, and Eunice began receiving a military pension on November 9, 1837. She lived a long life, dying on August 10, 1843.

In the late 1870s, Terrell's grandson Wyllys Jr. wrote a series of articles that were published in the *Elyria Constitution* newspaper just after the U.S. centennial. These articles shared stories of the early days of Ridgeville. He was the son of Terrell's son, Major Wyllys Terrell Sr., and Mary Molly Beebe (1783–1857). Molly was the daughter of another Revolutionary War soldier, Sergeant David Beebe Sr., and his wife, Lydia (Terrell) Beebe.

Wyllys Jr.'s articles contained secondhand and thirdhand memories but nevertheless provided valuable historical information. He wrote under the pseudonym of Old Hunter, but his identity was revealed upon his death. He shared stories of the Native Americans visiting the tavern; clearing the forest and building cabins; and wild bears, wolves and rattlesnakes. Now, on to the southern portion of Lorain County.

FORGOTTEN FOUNDERS AND LEADERS, SOUTHERN LORAIN COUNTY

Slowing creeping southward during the Glacial period, the ice filled the bed of Lake Erie, and rose till it surmounted the watershed between the Great Lakes and the Mississippi, which in Huntington and Rochester in the south part of Lorain County is fully 500 feet above Lake Erie.
—A Standard History of Lorain County, Ohio

The southern portion of Lorain County includes one city: Oberlin. Villages include Grafton, Kipton, LaGrange, Rochester, South Amherst and Wellington—with townships including Brighton, Camden, Carlisle, Columbia, Eaton, Henrietta, Huntington, New Russia, Penfield and Pittsfield, among others.

Columbia Township has the distinction of being the first part of the county that was permanently settled by New Englanders. In September 1807, approximately thirty pioneers left their homes, with at least half of them being children. It took them two months to reach Buffalo, New York, before traveling by boat. Their destination was the Cuyahoga River, but a storm caused them to go ashore and finish their journey on foot. Some wintered in Cleveland, but a few continued to hike through the wilderness, taking eight days to reach Columbia.

The first hardy pioneers built a log house and, as winter turned to spring and summer of 1808, people who stayed in Cleveland found their way to the budding new settlement.

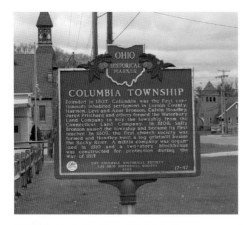

Left: This Ohio Historical Society marker commemorates the first continually inhabited settlement in Lorain County, Columbia Township, and the original settlers. *Tracy Isenberg*.

Below: The original log cabin in Lorain County's first settlement became its first schoolhouse in 1808, with Mrs. Bela Bronson the first schoolteacher. The house still stands in Columbia Township. *Tracy Isenberg*.

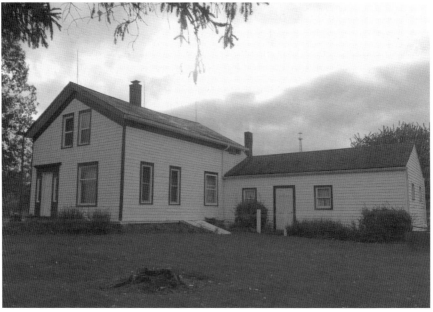

Officially organized as a township in 1809, Columbia originally was part of Geauga County. When the first elections took place, there were nineteen voters who selected trustees, a clerk, a constable and a justice of the peace. They saw no use in having a treasurer, so they didn't elect one. Because there were so many children in this new township, by the summer of 1808, the original log house had become a schoolhouse. Mrs. Bela (Sally) Bronson taught while the weather remained comfortable. By the winter of 1809–10, her husband taught the students blacksmithing, so they could learn a valuable skill that added heat to the building.

GRAFTON

In May 1816, approximately eighteen men left Berkshire County, Massachusetts, to travel to the Western Reserve. These pioneers included Jonathan and Grindall Rawson, John and George Sibley and Seth and Thomas Ingersoll. The purpose of the sojourn was to locate the land they now owned—or select from options available—and once that was accomplished, all but the Sibleys returned to New England. The men who remained were hired by the Rawsons to begin clearing the forest.

The Rawson brothers made this trip because their father, Samuel, had purchased 160 acres of land from the Connecticut Land Company. The following year, the brothers returned, along with Jonathan's wife, Dolley. Jonathan was going to develop parts of modern-day Grafton Township and parts of modern-day Eaton Township. Meanwhile, Grindall married Mariah Ashley, the first recorded marriage in this township.

The brothers, along with a man named Nathaniel Boughton, built a sawmill and gristmill, both completed by 1826. This was important because growing numbers of pioneers were arriving in the area. A man named Charles Fowler, who owned part of today's Eaton Township, bought up Jonathan Rawson's land after the railroad arrived, speculating that the area would grow in population.

In January 1852, the area was named Grafton Station. But because there were three areas with very similar names, this was confusing to railroad officials, so the name was changed to Rawsonville in May 1852. When the village was incorporated on New Year's Day in 1877, the name was changed to Grafton. The highlighted leader for this section was born when the area was still named Rawsonville, and he was quite the accomplished major league baseball player, one virtually forgotten today, even by avid baseball fans.

Edwin John "Mack" McKean

According to the April 14, 1900 issue of *Sporting Life*, "The passing of big Ed McKean and Patsy Tebeau, and the going of Clarence Childs to Chicago breaks up effectively one of the greatest infields that ever nudged elbows." And, one third of this outstanding outfield, Edwin John McKean, was born in what is today named Grafton. (As a side note before we go into more detail, "passing" in this context did not mean dying.)

Edwin McKean was considered an outstanding hitter, with a lifetime batting average of .302. Throughout his major league career, he chalked up 2,084 hits and 1,124 RBIs. Over thirteen seasons, he hit 67 home runs; for that era, one where the balls were of lesser quality, that was superb. He was also extremely reliable. Twice, he had the most at-bats for the season (1891 and 1895), and in four straight years (1893–96), he had a 100+ RBI season. In five seasons, 1891 and 1893–96, he scored 100 or more runs—and, in his first two seasons (1887–88), he stole more than fifty bases. That first year, he stole base seventy-six times. Of course, to be fair, he was also charged with ninety-nine errors that year—"Miscues aside, newspapers of the time applauded his hustle and enthusiasm."

McKean was born at the tail end of the Civil War, on June 6, 1864, to Irish immigrants Martin McKean (1829–1910) and Margaret Moran McKean (1836–1895). He had a brother, Martin B., and two sisters, Mary E. and Anna M. He married Belle Bridget Moran (1880–1952) in 1896, and the couple had three children: Edward John (1898), Robert D. (1901) and Mary Alice (1912). At least one source also mentions a son named Martin.

In 1884, he started to play minor league baseball for a team in Youngstown, Ohio, in the Iron & Oil Association league that consisted of teams from Ohio and Pennsylvania. He got his first hit in pro ball off "Cannon Ball" Bill Stemmyer, a man with whom he'd play professional ball in 1888. As a fun side note, Stemmyer only played one full season of professional baseball, and that was in 1886. He was fifth in strikeouts that year, with an average of 6.17 for nine innings pitched. He was also credited with sixty-three wild pitches, which is the second-highest number of wild pitches in professional baseball history. Couple Stemmyer's wild pitch season in 1886 with McKean's 1887 season with ninety-nine errors and then imagine what it was like to be a baseball fan in those days.

In 1885, McKean played for the Nashville Sounds of the Southern League. In 1886, he played for the Rochester Maroons and the Providence Grays of the International League. He was then picked up by a major league team, the Cleveland Blues. In the nineteenth century, major leagues tended to come and go, be created and fold, not like today's Major League Baseball, which has remained a stable force for more than a century. The Blues were part of a professional league called the American Association. In 1889, the team became part of the National League, and the team was renamed the Spiders. McKean batted .318 that year. He stayed with the team, which means that he was part of "one of the rowdiest teams of all time, the 1890s Cleveland Spiders." The team was a hitting powerhouse, known for its rough

play; although McKean played hard, he was noted for playing more cleanly than what was typical.

McKean's weaknesses included a throwing arm that wasn't impressive, and his tendency to put on weight off-season—as well as during the season. And in the 1892 season, it didn't help that he accidentally shot himself in the finger. In 1895 and 1896, the Cleveland team played in the Temple Cup Series, comparable to today's World Series. The team won in 1895 but lost in 1896.

Before the 1899 season began, the Spiders transferred the better players, including McKean, to another team owned by the same people: the St. Louis Perfectos. This is what was meant by passing in the opening quote. McKean had a poor season, though, and he was released from the team, never to play major league ball again. Statistics nevertheless show him as one of the era's great ballplayers, one of only four players in the nineteenth century to have at least two thousand hits, one thousand runs, one thousand RBIs and three hundred stolen bases.

Two years after his major league career ended, McKean returned to minor league play, becoming the player-manager of the Rochester Bronchos through the 1908 season.

After he was finished with baseball, he tried various business ventures involving wrestling, boxing and horse racing, and he opened a tavern in Cleveland, where he served as bartender. Known as a two-fisted drinker, his alcohol consumption only increased when he was surrounded by it daily. This led to gastric ulcers and other physical problems. McKean died at home on August 16, 1919, at the age of fifty-five. He is buried in the Calvary Catholic Cemetery in Cleveland.

As a side note, at least one biographer believes McKean was actually born in 1869, making him quite young when he started playing minor league ball and only fifty at the time of his death.

LaGrange

LaGrange is a village located at the intersection of Routes 301 and 303 with a population of 2,103 people as of 2010. LaGrange originally was Township Number Four, Range 17 in the Connecticut Western Reserve, owned by Henry Champion and Lemuel Storrs. In June 1824, this land became part of Carlisle Township, which was organized in 1822.

Champion deeded his property to his son-in-law Elizur Goodrich in 1825, who, in turn, began trading that land for New York property. So, many of the earlier settlers to LaGrange were from Jefferson County, New York.

The first permanent white settlers were Nathan Clark and his family, who arrived on November 14, 1825. Clark and his brother-in-law James Pelton built the first log cabin with the assistance of two other men. By spring of 1826, several other families had arrived; by the end of that year, the population had increased to sixty people, each of whom was needed to clear land, plant and harvest crops and otherwise create a viable settlement.

The original township was formed in April 1827 when it separated from Carlisle Township. The newly formed community of LaGrange was named after the French home of Gilbert du Motier, the Marquis de Lafayette. He was an officer in the American Revolutionary War, and his home was Château de la Grange-Bléneau. La Grange translates to "the barn" in French.

The first church was Baptist, formed under the auspices of Reverend Julius Beeman, who came from New York in 1827. The deal was that he would receive fifty acres of land in exchange for ten years of preaching. He followed through and also preached in nearby communities. The Methodist Church formed in 1833 and merged with the Congregationalists in 1867. Seventh-day Adventists, a group that organized in 1885, was another strong but somewhat later presence.

Two schoolhouses were built in 1828, on the east and west ends of the township. The only doors were hung on leather hinges, and the buildings were also used for religious services and meetings as needed. One man who was educated in LaGrange schools in his teen years went on to become an important mayor of Cleveland. Here's more about this accomplished politician whose life is largely forgotten today.

Robert Erastus McKisson

Robert Erastus McKisson's "name is written large on the pages of Cleveland's history through the practical reforms and needed improvements which he instituted while serving as mayor," according to *A History of Cleveland, Ohio: Biographical*, a book written in 1910.

Cleveland's thirty-third mayor was born on January 30, 1863, to Martin van Buren McKisson, originally a farmer, and Finette Adeline (Eldridge) McKisson. He was born in Northfield in Summit County in Ohio and first attended school in Cleveland before the family moved to LaGrange, where

he attended high school. Afterward, he studied at Oberlin College, paying the expenses through money he earned himself. His first job was that of messenger boy and then assistant in the Webster & Angell law offices. His original salary of five dollars per week at the law firm was increased as he proved his value. When McKisson turned nineteen, he began teaching, and he taught in multiple places in Ohio. When he turned twenty-four, he returned to Cleveland and began working in the offices of Senator Theodore E. Burton. During this time, he studied law and was admitted to practice in 1889. By 1891, he was practicing in front of federal courts. At first, McKisson worked as an attorney by himself, but he quickly became part of the renamed Webster, Angell & McKisson law firm, where he practiced through May 1, 1895.

By this time, he'd already begun his involvement in politics, serving on the Cleveland City Council starting on April 3, 1894. A year later (April 5, 1895), he became the city's mayor, with "his administration of the affairs of the office being of such a practical and progressive nature that he was recalled for a second term." McKisson was, in fact, the first Republican mayor to be reelected in the city of Cleveland. He'd come to the city "practically penniless and unknown" and became "recognized as a leader and one worthy of a large following."

He was noted for keeping his campaign promises, developing clear policies, managing expenses while not hampering progressiveness and more. He was a driving force behind the establishment and construction of a new water tunnel system and much of the sewer system. Park land increased from 123 acres to 1,400 acres under his oversight. He was the country's first mayor to "flush the city streets and in many other ways promoted the city's benefit, improvement and adornment." He was also involved in improving the river and harbor, straightening the first five miles of the river and deepening it to improve steamer traffic—and, therefore, trade in Cleveland. He also set aside funds for city hall. After his political career ended, he returned to the private practice of law.

His personal life may not have been as calm. McKisson married Celia Launetten Watring in 1891, but they divorced in 1900. His wife sued for divorce, under the provision of gross neglect of duty, and then he countersued using the same grounds. "At the hearing, which was secret, he testified that his wife no longer loved him. Mrs. McKisson did not contest the suit. Alimony, was agreed, upon outside of court."

The following year, on January 16, he married Mamie Marie Langenau, the daughter of a Cleveland businessman. They divorced in 1912. In

September 1915, he married Pauline E. Reed from Buffalo, New York, but he died three short weeks later, on October 14, at the age of fifty-two. He is buried in Lakeview Cemetery in Cleveland.

ROCHESTER

Near the southwestern tip of Lorain County on Route 511 is Rochester. In 2010, this village had a population of 182. This area was first organized into a township in 1835, the last of the townships in Lorain County to be created, with the first officers elected on April 6 of that year. Officers included John Conant, Joseph Hadley and Nehemiah Tinker. The clerk was M.L. Blair, and the treasurer was Benjamin Perkins. Perkins, who worked as a land agent, named the new township after his hometown in New York and is referred to as the father of the township in the *History of Lorain County, Ohio*. Rochester became a village in 1884 and kept its original name.

The first recorded birth in this township actually took place before Rochester officially became a township. The baby's name was Amy Banning, daughter of Elijah T. and Patience, and she was born on June 24, 1832. She married a man named Alexander Dolph and then moved to New London in nearby Huron Township.

The post office was established in 1837, with Hiram Woodworth chosen as postmaster. The condition of the post office's creation was that mail would be delivered at no cost to the government, so John Clark agreed to carry the mail at no charge. Early commerce included a store and hotel built by George G. Ogden in about 1848. Other enterprises included the general store, J.B. Carrison & Son, a pharmacy, a grocer and a tin shop.

The first church built was Methodist, begun in 1833 with four original members. A Congregational church was built in 1838, a Baptist church in 1842 and a United Brethren church in 1852. The first school was in a log house and was associated with the Methodist Church, with classes started in 1833–34 under the instruction of Abigail Tinker.

Bishop Walden Perkins

Small as the village is, though, a state representative and senator was born there on October 18, 1841. Bishop Walden Perkins experienced numerous adventures in his fifty-two years of life, attending common schools and Knox

College in Galesburg, Illinois. From 1860 to 1862, the lure of the gold rush summoned him to California and New Mexico—and that was before he served in the Union army as a sergeant, adjutant and captain.

Perkins then moved to Ottawa, Illinois, where he studied law. Admitted to the bar in 1867, he practiced law in Princeton, Indiana, then in Oswego, Kansas. He served as the local county attorney for the Missouri, Kansas and Texas Railroad for the next two years; in 1869, he served as the prosecuting attorney of Labette County. Then, he settled into one steady occupation from 1870 to 1882: probate court judge of Labette County. As if that wasn't enough to keep Perkins busy, he married an Ohioan named Louise E. Cushman around 1872. The couple had at least two children (Josephine in 1876 and Bishop Chaplin in 1878). In 1873, he also became the editor of the *Oswego Register*.

He then moved to the national politics scene, elected as a Republican to the 48th U.S. Congress; he was reelected three times, serving from March 4, 1883 to March 3, 1891. During that time, he had a town named after him, and here's how that happened. On April 22, 1889, Congress opened new land for settlement, today's Oklahoma. About 20 men applied to register a town they wanted to name Cimarron. According to law, though, 150 settlers were needed to register a town, which seemed absurdly high to these men. So, they came up with a smoke-and-mirrors kind of plan.

As OkTerritory.org tells it,

> [S]everal men went to Guthrie and brought back a load of shingles. Under the direction of William A. Knipe, these shingles were marked with names taken from memory and a townsite staked out on what was known as the Wert homestead. Later, as settlers came in, real estate began to change hands rapidly, with the names of actual settlers being substituted on lot stakes and records for the fictitious and imaginary first settlers.

The name of that town was changed to Italy because of the sunshine. By this time, Italy had two stores, five houses, a school and about forty residents. A mayor was elected, along with five councilmen, a town treasurer and clerk. But, they desperately needed a post office, so they contacted Representative Perkins, a member of the House Committee on Territories. After he arranged to provide them with a post office and a mail stagecoach (effective January 30, 1890), the post office was named Perkins. On July 10 of that year, an application was submitted to change the town's name to Perkins, and it was approved.

Ironically, Perkins lost his reelection bid that year, but the death of well-respected Preston B. Plumb ushered in his next career move. Plumb, also an Ohioan, was a three-term Kansas senator who was considered a founder of the state. He had been a strong Free Soil Party abolitionist and a Union army officer who became a Republican. In the summer of 1891, Plumb became ill and was told by doctors to retire and travel to Europe to convalesce. He refused, not willing to back down from a political battle between the Republicans and an ascending Populist Party. He died of his illness, and Perkins was chosen to fill the vacancy. He served in the Senate from January 1, 1892 to March 3, 1893.

Perkins then resumed the practice of law, this time in Washington, D.C., but he died on June 20, 1894, and was buried in Rock Creek Cemetery.

WELLINGTON

The town of Wellington was first settled in the spring of 1818 when Ephraim Wilcox, Charles Sweet, William T. Welling, John Clifford and Joseph Wilson traveled to Ohio from their homes in Berkshire County, Massachusetts, and Montgomery County, New York. Upon arriving, they chopped away enough of the forest to allow the sunshine to come through—and that's where they built the first log cabin.

Legend has it that Wellington was meant to be named through a tree-chopping contest, and perhaps this initial clearing of trees is the source of the story. The man who agreed to cut down the most trees, according to the tale, won the right to name the settlement. According to the story, Charles Sweet bid the most (eighty rods) and decided to name the town Charlemont. However, most of the other settlers objected to the name and decided that Wellington was a better choice. Some claim that the townsfolk chose the name Wellington in honor of the Duke of Wellington, a contemporary war hero associated with Napoleon's abdication, while others say that it was named after William T. Welling, one of the town's other original settlers.

No matter how it received its name, Wellington was located about ten miles from the settlement of Grafton. Men traveled there in pairs to get their bread baked. No one wanted to go alone because of all the wild animals in the region.

The following July, families began to arrive, with a school started in the spring of 1820, and the settlement was officially recognized as a township in

April 1821. Wellington gained prosperity in the 1840s with the growth of the carriage-making industry. Businesses such as Tripp's Carriage Depot fueled the town's economy from the mid-1840s to the 1880s. With the construction of the railroad in 1850, Wellington became even more economically successful and was incorporated as a village in August 1855.

In the 1870s, the town's industry had shifted toward cheese production, and Wellington earned the title Cheese Capital of the World. Wellington was the home of over forty factories that shipped 6,475,674 pounds of cheese and 1,100,661 pounds of butter around the country in 1878.

Although the town's last cheese factory closed in 1912, Wellington remains a part of national history. It is the site of the historic Oberlin-Wellington rescue, during which a runaway slave was saved from slave catchers. It was also the home of Myron T. Herrick, governor of Ohio and U.S. ambassador to France, as well as Archibald M. Willard, painter of the famous work *Spirit of '76*.

Archibald Willard

Archibald Willard was born on August 22, 1836, in Bedford, Ohio. By the mid-1850s, his family had moved to Wellington because his father, the Reverend Samuel Willard, was asked to serve the Church of Christ there. Young Archibald loved to draw, and he would use carpenter chalk and coal for drawing materials. Because of his talent, he became an apprentice at E.S. Tripp's Carriage Depot. Willard learned how to paint carriages and furniture in the shop, giving him his first training as an artist. He exceled in creating fancy carriage striping and adding landscapes on the wagon boxes. Not surprisingly, Tripp carriages won blue ribbons at the Ohio State Fair.

During the Civil War, Willard enlisted in the Eighty-Sixth Ohio Volunteer Infantry of the Union army. During his time as a soldier, he gained more experience as an artist by drawing pictures of what he saw in the war. He sold some to *Harper's Magazine* and others to soldiers who appreciated his work. After the war ended, Willard sent two pictures to a Cleveland art dealer, James F. Ryder, to be framed: *Pluck—Number One* and *Pluck—Number Two*, which depicted children in a runaway dogcart. Ryder put them in his store and also made chromolithographic copies, which he sold for ten dollars per pair. Willard earned enough from these sales to attend art school in New York.

Although Archibald Willard from Wellington is best known for his *Spirit of '76* painting, he was a much more prolific painter. Here is *Children on a Runaway Cart. Library of Congress.*

Willard's most famous work is the *Spirit of '76*. The story that describes its creation has a few variations, and here is one version. Willard initially drew a humorous sketch inspired by the light-hearted marching of the Brighton Fife & Drum Corps. In response, Ryder convinced Willard to paint a patriotic work for the upcoming centennial exposition to be held in Philadelphia in 1876. Willard began working on the painting, ultimately creating a more somber patriotic work than his original sketch.

Willard had set up a studio in Cleveland in 1875, and he used local models for the figures in the painting: Hugh Mosher, a fellow Civil War veteran, posed for the fife; Henry Devereux, the son of General John Devereux, posed as the junior drummer; Freeman Green originally posed as the man beating a drum, but he quit before the painting was completed and was replaced by Willard's father, Reverend Samuel Willard.

Willard completed the eight- by ten-foot painting in time for the exposition and named it *Yankee Doodle*. It was displayed at the centennial exposition in Philadelphia, where most art critics derided the work. The public, however, was taken by the art, which seemed to exemplify the American spirit. Legend says that President Ulysses S. Grant wept when he saw the painting.

Yankee Doodle went on a national tour after the exposition and gained the title *Spirit of '76*. Afterward, the work was purchased by General Devereux. Willard's partner Ryder created several prints and reproductions of the work to sell to the public. The national exposure of the painting as well as the patriotic pride it evoked helped Willard's creation become one of the most famous American paintings.

Willard painted multiple versions of the work, mainly as gifts to family and friends. All the subsequent originals were smaller than the first, and some were painted in watercolor rather than oil. Willard also added background details in some of his later versions, such as munitions houses or other groups of soldiers. He painted new works as well, preferring military themes, as well as landscapes.

Willard died on October 11, 1918. He is buried in Wellington in Greenwood Cemetery. The first version of his famous work *Spirit of '76* now hangs in Abbot Hall in Marblehead, Massachusetts. Other originals hang at the Department of State headquarters in the White House, the Western Reserve Historical Society in Cleveland, Cleveland City Hall and the Herrick Memorial Library in Wellington.

LORAIN COUNTY CEMETERIES

According to Jeff Sigsworth, past president and co-founder of the Lorain County Chapter of the Ohio Genealogical Society, approximately seventy-eight cemeteries exist in the county. Yes, seventy-eight. There are eleven in Amherst Township alone, which consists of the city of Amherst, much of South Amherst and a bit of the city of Lorain. So, even an entire book dedicated to the fascinating history found within Lorain County cemeteries would still be only skimming the surface.

COLUMBIA CENTER CEMETERY, COLUMBIA TOWNSHIP

This cemetery dates to 1811, four years after Columbia Township was settled, when nine early settlers died of an ague epidemic. This cemetery needs to be included in this book, in part because it's the oldest in the county, but also because five Revolutionary War veterans are buried here, along with numerous veterans from the War of 1812. The site chosen for the cemetery overlooks the Rocky River Valley and was an area initially cleared for the cabin of Bela Bronson; at least three members of the Bronson family are buried here, as well.

The cemetery has a marker for a Mexican War veteran, too—a man named Harry Bastard who is not actually buried there. Here's some backstory. Bastard was born in England on July 23, 1820, to Harry Bastard

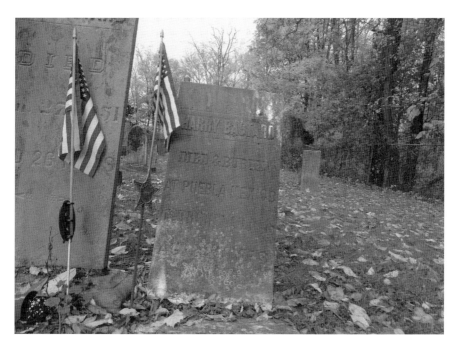

This gravestone commemorates Harry Bastard: born in England, he came with his parents to the United States and settled in Columbia Township. He fought in the Mexican War and died of typhus fever. *Tracy Isenberg.*

Sr. and Elizabeth Churchward. He and his parents and siblings (Philip, Robert, Thomas, William, Elizabeth and Martha) sailed to America on the SS *Barque Cosmopolite* in 1835. They settled in Columbia Township, with the children marrying the children of Thomas and Susanna Squire. Nearly all of them are buried in Columbia Center Cemetery.

Harry enlisted in the Mexican War on April 14, 1847, as a private in the Company G, Fifteenth Infantry, but he died less than a year later (March 11, 1848) of typhus fever at the age of twenty-eight. He was buried in Puebla, Mexico, but his name is also listed on a stone in Columbia Center Cemetery.

Harry's unit had been activated for service about two months before he joined. The recruits traveled to Vera Cruz, where they joined with General Winfield Scott and his advance on Mexico City. Two of the biggest battles fought by this unit—at Contreras and Churubusco—took place while Harry was enlisted. The unit was deactivated, and its men returned to the United States in 1848.

This cemetery is located on the east side of Columbia West River Road, slightly north of Route 82.

BROWN'S LAKE ROAD CEMETERY, BROWNHELM TOWNSHIP

Older cemeteries, especially smaller ones, all too often get forgotten, and this is a perfect example. Members of the Brownhelm Historical Society believe burials in this cemetery largely featured wooden tombstones, ones that naturally rotted away over the decades, and eventually, everyone who knew about this cemetery in Brownhelm Township died. Several years ago, though, detection dogs trained in recovering human remains came to what is now called the Brown's Lake Road Cemetery three different times. The dogs indicated 123 places where they detected bodies. Local volunteers who cut away overgrowth around the few existing tombstones say some of these burials took place as far back as the early 1800s.

It is known that Colonel Henry Brown purchased half an acre from Levi Shepherd and half an acre from Stephen James to establish a burying ground for the new community, and many early settlers are buried in the cemetery. Because of this, and because he is considered the founding father of Brownhelm Township, the people restoring the cemetery named it in his honor.

Modern-day volunteers coordinate their maintenance efforts with the City of Vermilion—a city with its eastern portion in Lorain County, western in Erie County. The cemetery is located at 1863 Liberty Avenue in Vermilion, slightly west of Baumhart Road. No official plot records exist, and vandalism in the 1940s likely caused even the few remaining tombstones to be moved from their original positions.

One of the tombstones that remains is for Colonel Brown. Sadly, his daughter Charlotte was one of the first settlers buried here. Colonel Brown fought in the War of 1812; another soldier, this one from the Revolutionary War, is buried there: Bildad Belden. He was apparently born in 1745, even though his tombstone reads 1742. One theory is that his headstone was purchased in the 1840s, a couple of decades after his death, so the date of his birth had gotten confused in the meantime. His date of death is recorded as August 4, 1824.

Bildad was born in Wethersfield, Connecticut, on September 9 to Samuel and Elizabeth Belden. He married Mary Riley, and the couple had five children. The names of the children were Bildad Butler, Elizabeth (who died in 1782), Susannah (who also died that year), Clifford and Rosanna (who died in 1770).

CHARLESTON CEMETERY, LORAIN

Charleston Cemetery, Lorain's original cemetery, was virtually forgotten and considered a city park until Diane Wargo Medina spearheaded efforts to restore it to a cemetery. *Courtesy of Diane Wargo Medina.*

This Lorain cemetery was almost forgotten, but it was restored through the efforts of volunteers led by Diane Wargo Medina. Charleston Cemetery contains the tombstones of two city founders, Daniel T. Baldwin and Barna Meeker, along with Civil War veteran Augustus Silverthorne and Clarissa Kneeland Porter. The latter's descendants became well-known merchants.

Formerly known as Old Bank Street Cemetery, the Charleston Cemetery is located between Oberlin and Hamilton Avenues, between the Sixth and Seventh Street blocks, and is the city's first public burial ground. The cemetery is currently less than one acre, located in a residential neighborhood.

Charleston Cemetery was used until the 1880s, and then houses were built over top of the grounds; over the years, grave markers were destroyed or buried, with the deadly June 28, 1924 tornado demolishing much of this part of town. Remains were said to have been relocated to the Elmwood Cemetery as the area developed into a residential one, but research has not confirmed this. After the 1924 tornado, the area was used as a public park.

When Medina was a teenager, she began to imagine what the vacant-looking property was like when it was a cemetery, and she began unearthing stone slabs. Stones that were salvageable have been repaired on a small budget, while others have been replaced. Funds have come from the Charleston Village Society Inc., the Lorain Historical Society, the Black River Genealogists, the City of Lorain and friends and family. Improvements include electricity and running water, along with iron archways at both entrances, fencing, a new flagpole and name plaque preservation.

Local Girl and Boy Scouts have helped with landscaping, and tours have been given to local schoolchildren and more. Loraine Ritchey of the Charleston Village Society has documented its history and renovations in her blog.

Augustus Silverthorne may have been born in New York. On December 21, 1863, he enlisted in the 128th Ohio Infantry, Company F, of the Union army. He served until being discharged on January 19, 1865, about three months before Confederate general Robert E. Lee surrendered on April 9, 1865, to Union general Ulysses S. Grant. He was discharged because of disability and given a surgeon's certificate. He didn't live long past the war's end, dying on February 27, 1866, and never married. On Memorial Day, local veterans put a flag and wreath on his grave.

ELMWOOD CEMETERY

Robert John Cowley was born in Cleveland on November 2, 1839 to Robert A. (a shipbuilder and "sea-faring" man) and Catherine (née Cain). He was educated in Cleveland's public schools and learned the shipbuilding trade, working as a "man before the mast." He was in New Orleans when the Civil War broke out and quickly headed north, coming to Lorain in 1861. He then joined the U.S. Navy in 1864, participating in the West Gulf blockade under Commodore David Glasgow Farragut. As the Union army attacked the bay, they realized it was heavily mined; tethered naval mines were called "torpedoes" at the time. Union ships began pulling back as they witnessed other ships being struck by these mines, and Farragut uttered the following words: "Damn the torpedoes. Four bells, Captain Drayton, go ahead. Jouett, full speed." That probably doesn't sound familiar, but the paraphrased version that is more often quoted might: "Damn the torpedoes! Full speed ahead."

While the navy was trying to capture Mobile, Cowley's gunboat was blown up by a torpedo, with half of the crew wounded or killed. Cowley, however, survived. Farragut's unit, including Cowley, were victors in the Battle of Mobile Bay on August 5, 1864. This was a crucial victory because it was the last major open port for the Confederacy on the Gulf of Mexico.

Cowley returned to Lorain, sailing the lakes. He married Celia Elizabeth Lyons (1845–1917), a woman with connections to Lorain's early families. They had a daughter, Katherine, in 1867, who married into the Wire family. He died on July 21, 1911, and is buried in the far northern section of Elmwood Cemetery in Lorain, behind the chapel.

RIDGELAWN CEMETERY, ELYRIA

Ridgelawn Cemetery is Elyria's original cemetery, located at 285 Columbus Street. People buried there include Heman Ely, considered the founder of the city, and Easter Seal's founder Edgar Fiske Allen. Yet another person of acclaim buried in Ridgelawn Cemetery is Congressional Medal of Honor winner George Butts.

Butts was born in Rome, New York; his date of birth is sometimes listed as 1838, but his tombstone reads 1843. He enlisted in the U.S. Navy and fought in the Civil War as a gunner's mate. While on the USS *Signal*, his ship was traveling on the Red River in May 1864, conveying the *John Warner* below Alexandria, Louisiana, where they encountered Confederate batteries and sharpshooters.

The *Signal* was assigned to guard the transport *John Warner*, which was carrying Union soldiers on furlough, including those from the 56th Ohio Infantry, as well as hundreds of bales of cotton confiscated from Confederates. It began its journey on May 4, 1864, departing from

The Civil War monument, located in Ridgelawn Cemetery, honors the men from Elyria who fought in the war. Congressional Medal of Honor awardee George Butts is buried here. *Tracy Isenberg.*

Alexandria, Louisiana, to meet the *Warner* and *Covington* at the mouth of the Black River, then help escort the *Warner* to the mouth of the Red River. On its way to meet the two ships, the *Signal* picked up a group of 120th Ohio Volunteer soldiers, whose ship, the *City Belle*, had wrecked.

The *Signal* met the *Warner* and *Covington*, and the three ships continued without incident until around five o'clock in the morning, when the *Warner* rounded a bend in the river near Snaggy Point and was attacked by Confederate soldiers. The Rebels fired cannonballs and Minié balls at the *Warner* from high riverbanks, damaging the ship's pilothouse, rudder, paddlewheels and several pipes while killing and wounding many soldiers on the upper deck. Officers ordered the remaining infantrymen to abandon ship and escape into the woods.

The *Covington* and the *Signal* continued to fight despite the *Warner's* surrender. Butts and fellow gunner Charles Asten left the *Signal's* sick bay to return the Rebels' fire. But Confederate fire damaged the tinclad's pilothouse steering wheel and sheaves, making steering impossible. The *Covington* also was disabled once the soldiers on the bank damaged its rudder. The captain ordered the surviving crew to abandon ship, then set the *Covington* on fire and fled with his remaining men to Alexandria. The Confederate soldiers then turned their attention to the *Signal*. At around 11:00 a.m., the *Signal* finally prepared to abandon ship and escape. But before the six officers and forty-eight crewmen could flee, they were surrounded by soldiers and forced to surrender. The Confederates salvaged the useful parts from the *Signal* and took the officers and crew to the Camp Ford prisoner-of-war camp near Tyler, Texas.

Throughout the engagement, Butts—who had been on the sick list—courageously performed his duties. He was one of those taken prisoner and, after being exchanged, was awarded the Congressional Medal of Honor on December 31, 1864. He died on February 17, 1902.

PITTSFIELD CEMETERIES

The first cemetery established in Pittsfield, the Pittsfield East Cemetery, was first used in 1834. The cemetery is located on State Route 303, one third of a mile east of State Route 58. The Pittsfield South Cemetery was started about the same time and is located on State Route 58, about half a mile south of State Route 303. Finally, Jackson Cemetery is located on the

north side of Webster Road in the southeast corner of the township. Charles Rounds, a Revolutionary War veteran, was buried there in 1843 at the age of eighty-four. The earliest date on a tombstone is 1837: Daniel G. Saxton.

The Pittsfield East Cemetery sustained significant damage from the 1965 tornado (not to be confused with Lorain's 1924 tornado), and it contains the tombstone and remains of Lucy Bradford McRoberts. Lucy is a direct descendent of William Bradford, who came to the colonies on the *Mayflower* and ultimately served as governor of Plymouth. William was from York County, England; his wife, Dorothy May, was from Amsterdam, Holland. In 1620, they sold their home and traveled to the colonies, leaving their young son, John, behind. When the *Mayflower* anchored off Provincetown Harbor on November 11, several men looked for a place to settle. Bradford went on one of these exploration jaunts, and while he was gone, on December 7, Dorothy fell overboard and drowned.

After the original governor of Plymouth, John Carver, died in April 1621, Bradford became governor and was reelected nearly every year after that. In 1623, he married Alice Carpenter Southworth, a widow, and they had three children: William, Mercy and Joseph. Here's more about Lucy Bradford, who is buried in Pittsfield.

Lucy Bradford McRoberts, buried in Pittsfield, is a direct descendent of William Bradford, who came over to the colonies via the *Mayflower*. William served as a longtime governor of the Plymouth settlement. *Tracy Isenberg.*

Lucy Bradford was born in October 1761 in Springfield, Massachusetts, one of five children of Simeon Bradford (1729–1793) and Phoebe Whiton Bradford (1736–1794). She married John McRoberts in approximately 1781, when he was about twenty-three years old. The couple had seven children, all of whom lived to adulthood, and all but Jane are buried in East Pittsfield Cemetery.

James McRoberts (1786–1864)
Mary McRoberts Worcester (1790–1877)
Synthia McRoberts Sheldon (1793–1878)
Lucetta McRoberts Hall (1796–1889)
Jane McRoberts Hall (1799–1828)
Balsora McRoberts Clark (1808–1883)
Peter McRoberts (1804–1847)

John fought in the Revolutionary War, died in 1813 (age fifty-two) and is buried in Vermont.

Most of Lucy's children moved to Ohio, except Jane, who died as a young adult in Vermont, but Lucy remained in Vermont until she moved to Pittsfield, Ohio, in 1845, shortly before her death on July 27 at the age of eighty-three. She was the first of the family to be buried in East Pittsfield Cemetery, but Peter, her youngest son, died two years later and is buried next to her. Two of Peter's sons, Charlie and Erwin, fought in the Civil War and then worked on the railroad.

Much of this history was lost until July 2010, when cemetery volunteers were performing acts of preservation. Both Lucy's and Peter's gravestones were uncovered, along with a monument that listed the names of Lucy, Peter and his wife, Eliza, and the two sons who'd fought in the Civil War: Charlie and Erwin. A descendant of Lucy speculates that this monument was created shortly after Charlie and Erwin died, in 1870 and 1872. Most likely, Peter's other sons—Volney, Pitt and Henry—commissioned this monument.

The McRobertses were instrumental in the development of the school system, with the 1858 schoolhouse's property leased to the board of education by Eliza for $20 (about $563 in today's dollars). In 1881, Henry sold the property for $41.87 (about $1,226 in today's dollars), and the school became known as McRoberts School. On July 2, 1891, the Pittsfield Township Special District No. 2 was officially formed, with Volney McRoberts serving on the original school board. On July 27, the old schoolhouse was for sale, and "A. McRoberts" purchased it for $48, with "H. McRoberts" buying the

storage house. A brick McRoberts School House was built and used from 1891 to 1940, and then the township's education district became part of the Oberlin School System.

Westwood Cemetery, Oberlin

Westwood Cemetery is one of the most historically significant sites in Oberlin. Originally, the Town of Oberlin leased a two-acre stretch of land along Morgan Street from Oberlin College to use as a cemetery. By 1861, however, the small cemetery was nearly full, and more interments might be expected as the Civil War continued. The Oberlin Cemetery Association managed to buy twenty-eight more acres of land, and the Westwood Cemetery was formally dedicated on July 16, 1864.

Westwood Cemetery is now the resting place of many individuals who shaped Oberlin's history. Reverend Charles Grandison Finney (1792–1875) was the pastor of the First Church in Oberlin, a professor of theology at Oberlin College and the college's second president. General Giles W. Shurtleff (1831–1904) was a Civil War hero who led the Fifth U.S. Colored Troops. Adelia A. Field Johnston (1837–1910) was Oberlin College's first female faculty member and acted as principal of the Women's Department, dean of women and professor of medieval history.

Another one of Westwood's historically important graves belongs to Lewis Clarke, who was born a slave in Kentucky but escaped to Ohio and became

Uncle Tom's Cabin is often mentioned as one of the most influential books about slavery. The man who likely inspired the character of George Harris, Lewis Clarke, is buried in Oberlin's Westwood Cemetery. *Library of Congress.*

an abolitionist. Clarke is said to have partially inspired the character George Harris in Harriet Beecher Stowe's novel *Uncle Tom's Cabin*. Lewis was born in Kentucky in 1815, the son of slave Letitia Campbell and Scottish weaver Daniel Clarke. Lewis lived with his parents and eight siblings until he was six years old. In 1821, Letitia's owner Samuel Campbell died, and his heirs split up and sold the mother and children.

Lewis was sent alone to become the slave of Betsy Campbell Banton, Samuel's daughter, and her husband, John. The Banton home was a cruel one, and Clarke describes the recurring whippings he received, as well as the constant threats of even worse punishments. Clarke was, in fact, Betsy's nephew; Letitia was the illegitimate daughter of Samuel Campbell and one of his slaves. Clarke claims that this relationship made her treat him especially cruelly: "Mrs. Banton, as is common among slave holding women, seemed to hate and abuse me all the more, because I had some of the blood of her father in my veins."

Clarke was sold by the Banton family in 1827 (because of financial difficulties) to General Thomas Kennedy. The Kennedys decided to hire out Clarke's time, allowing him to travel the area on horseback to weave, split rails and sell grass seed to earn money for the Kennedys. This was Clarke's first taste of relative freedom, which only made him desire true freedom even more. After his owner died in 1840, Clarke heard rumors that he would be sent to Louisiana, a state that was said to treat its slaves the worst. Clarke decided to escape: "I had long thought and dreamed of LIBERTY; I was now determined to make an effort to gain it."

Clarke made his first escape from Kentucky in 1841. He set out alone on horseback and reached the Ohio River in two days. He later wrote of his arrival in Ohio:

> *When I stepped ashore here, I said, sure enough, I AM FREE. Good heaven! what a sensation, when it first visits the bosom of a full grown man—one, born to bondage—one, who had been taught from early infancy, that this was his inevitable lot for life. Not till then did I dare to cherish for a moment the feeling that one of the limbs of my body was my own.*

Now that he had obtained his freedom, Lewis began tracking his brother Milton, whom he learned had escaped Kentucky a few months previously. Lewis eventually found his brother in Oberlin. Reunited with one brother, Lewis decided to help another sibling, Cyrus, escape slavery as well. Lewis managed to successfully return to Kentucky and escape once again with his

brother. Once safely in Oberlin, Cyrus continued traveling to Canada while the other two brothers decided to stay in Oberlin for a few more days.

While in Oberlin, Milton was recognized by two bounty hunters who had been hired by his former owner. The bounty hunters later captured Milton and attempted to take him back to Kentucky. Lewis used his connections in Ohio to procure two writs from Lake County and Ashtabula County to arrest the bounty hunters as kidnappers. Milton was freed, and both men were arrested, then released to return empty-handed to Kentucky.

This experience convinced Lewis and Milton to move to the Northeast. Lewis lived in New York for a while before moving to Cambridge in 1842. There, he became even more involved in the abolitionist movement, helping more slaves escape, giving lectures throughout the Northeast and publishing his experiences. Clarke's *Narrative of the Sufferings of Lewis Clarke* was dictated by pastor Joseph C. Lovejoy, published as a pamphlet in 1843 and sold at abolitionist meetings. A hardcover edition was published in 1845. A year later, Lewis published *Narratives of the Sufferings of Lewis and Milton Clarke, Sons of a Soldier of the Revolution*, a slight alteration to his first story that added Milton's experiences escaping slavery.

Harriet Beecher Stowe published her book *Uncle Tom's Cabin* in 1852, seven years after Clarke's *Narrative*. Her character George Harris bears remarkable similarity to Clarke. Both were born in Kentucky to a mulatto slave mother and a white father, and both were separated from their families at a young age. Certain details of Harris's escape also match Clarke's, such as staying the night in a tavern while wearing a disguise. Stowe herself notes in her book *A Key to Uncle Tom's Cabin* that Lewis Clarke was an acquaintance of hers and that much of Harris's life is comparable to Clarke's. However, Stowe also mentions other "slaves of our personal acquaintance" that inspired Harris's story. Clarke was not the sole inspiration for the character of George Harris, but it's clear that he had an influence on Stowe's creation.

Clarke eventually returned to his home state of Kentucky, where he died in December 1897 at the age of eighty-two. His body lay in state in the Lexington City Auditorium for four hours, where he was visited by thousands of people. His obituary noted that "[n]o such honor has ever before been paid a negro in Kentucky, or the south." He was then moved to Oberlin and buried in Westwood Cemetery with a tombstone reading "The Original George Harris of Harriet Beecher Stowe's Book Uncle Tom's Cabin."

FAMILY CEMETERIES IN LORAIN COUNTY

Perhaps the most vulnerable cemeteries, the ones most likely to be forgotten, are family cemeteries—and Lorain County has contained several. The Crandalls buried their family members at the intersection of State Routes 113 and 58, with their tombstones and remains eventually moved to Kendeigh Cemetery, a public burial ground located on the east side of Quarry Road, slightly north of the Ohio Turnpike. Kendeigh Cemetery was originally established in 1863 next to an even older burial ground. Later, land was bought in 1895 to expand the cemetery.

Stones from the Crandall family include those of Lyman (1812–1897) and his wife, Eliza (1814–1894). Rhoda Crandall also has her gravestone here, and she is listed as the consort of Ezehiel; she died on March 14, 1818, at either the age of thirty-five or thirty-seven. Finally, Eliza, wife of Asabel, has her stone in Kendeigh Cemetery. She died on March 6, 1838, at the age of thirty-seven.

Stones from the Onstine family cemetery, originally located on the northwest side of Cooper Foster Road, just one mile west of Oak Point Road, were also moved to the Kendeigh Cemetery. The oldest stone was Christina Onstine's, who died on February 12, 1823, at the age of twenty-four. One dozen others with the Onstine surname have stones, including Frederick, who was born on December 21, 1760 (d. May 20, 1837), and his wife, Elizabeth, who died on January 6, 1842, at the age of eighty-three years, ten months and six days. Another member of the Onstine family had the quaintly lovely name of Remember (d. March 6, 1860 at the age of sixty-six years, two months and three days). Other family members have the names of Daniel, Susan, Ann, Henry, Philip, Andrew, Catherine, Sarah— and another Frederick. Several people with other surnames had also been buried there.

In Brighton Township, there is the Loveland family cemetery on Quarry Road, north of State Route 18. These graves are now located at the southeast corner of Echo Valley Golf Course and include that of Whitlock Loveland, the first permanent white settler to die here. He was born on January 2, 1820, to Leonard H. and Margaret L. Loveland. He only lived ten short months, dying on October 13, 1820. He was buried in what was then the family farm, south of their log cabin. Several other family members were later buried near him.

The Claus family cemetery is located in Brownhelm Township near the location where Lorain and Vermilion meet, on the south side of State

Route 2, just east of the former Ford Plant. Unfortunately, this cemetery was surrounded by the Lorain Sewage Disposal Plant. The first person buried there was Lucy Morgan on April 9, 1855, at the age of eighty, the only adult buried in this now-desecrated cemetery. Four children are known to have been buried there.

Finally, the Clifford family cemetery—containing four stones—was located on the north side of State Road 18, about a quarter of a mile east of Wellington, and wasn't visible from the road. The graves were moved to Greenwood Cemetery, section 10, in Wellington. The earliest was Mary Brandberry, who died in July 1819; the other people died in 1860 or before, although some dates are now illegible.

4

UNDERGROUND RAILROAD
AND CIVIL WAR HISTORY

O berlin—called the town that started the Civil War because of its blatant abolitionism—is well known for its role in the Underground Railroad. Meanwhile, the rest of the county is not as well known for its contributions. Yet as this chapter will show, much of Lorain County played a crucial role in the abolitionist movement—and even more so in the war, with *A Standard History of Lorain County, Ohio* noting that, even in the relatively small Sheffield, "Six of the Ilyland brothers were killed or died of disease during the war."

Here's an overview of why Lorain County ended up being such a hot spot of abolitionism in an era when helping fugitive slaves was illegal and could come at a high cost for Underground Railroad participants. First, the unofficial president of the Underground Railroad, Levi Coffin, was an Ohioan. Living in Cincinnati, he was said to have helped thousands of slaves ultimately find freedom in Canada. His location in southern Ohio was crucial because the slave state of Kentucky was located on the other side of the nearby Ohio River.

Meanwhile, Presbyterian minister John Rankin and his wife, Jean, intentionally put their house directly on a hill above the Ohio River in Ripley so that escaping slaves in Kentucky could watch for a signal indicating it was safe to cross the river. The couple would shelter them and help them move farther north. Rankin's neighbor, John Parker, would help slaves to cross the river in a boat. One account from 1831 states that the Underground Railroad even got its name from an Ohio River crossing. It may have come from

when fugitive Tice Davids swam across the river while his owner paddled a boat in pursuit. When Davids reached the shore, just a few minutes before the owner, he seemingly disappeared, with a comment made that the slave "must have gone off on an underground road."

Once in Ohio, the goal was to get the fugitives to northern Ohio and ultimately across Lake Erie to Canada (although some stayed in Ohio, particularly in Oberlin). There were several cities where the transport to Canada typically launched, including Lorain.

OBERLIN-WELLINGTON SLAVE RESCUE

Another town south of Oberlin played a crucial role in abolitionism: the town of Wellington. Here's the amazing story of the Oberlin-Wellington Slave Rescue.

John Price was a young man who had escaped slavery in Kentucky and lived in Oberlin for two years. On September 13, 1858, twelve-year-old Shakespeare Boynton, son of Lewis Boynton, offered Price work picking potatoes on his family's farm. The work, however, was a trick set up by Lewis Boynton and two Kentucky slave catchers: Anderson Jennings and Richard Mitchell. Rather than taking Price to the farm, the buggy was stopped by the slave catchers as well as federal marshal Jacob Lowe and his assistant Samuel Davis, who had a warrant for Price's arrest and return to his owner in Kentucky. The group forced Price into their carriage and traveled eight miles to Wellington to board the 5:13 p.m. train to Columbus.

American House is the structure where the highly controversial Oberlin-Wellington Slave Rescue took place in September 1858. *Courtesy of Al Leiby.*

An Oberlin student recognized Price on the road and understood his situation, then went back to Oberlin to spread the news throughout town. Many residents decided to pursue the slave catchers and rescue Price. The residents made their way to Wellington and eventually tracked the group to the Wadsworth Hotel. The slave catchers posted guards at the door and barricaded themselves in the hotel's attic. By afternoon, a crowd of between two hundred and five hundred people, residents of both Oberlin and Wellington, had gathered outside the hotel.

The crowd first tried nonviolent methods to free Price, shouting back and forth with the slave catchers to release him. One Oberlin man, Charles Langston, tried to convince the village constable to arrest the slave catchers for kidnapping. He then tried to secure a writ of habeas corpus for Price and, when that failed, attempted to negotiate with Lowe for Price's freedom. After the peaceful methods failed, the crowd forced themselves into the hotel. Three men rushed the guards, allowing some of the rescuers into the building to help Price escape. Price was taken back to Oberlin and hid in the home of James Fairchild, a professor at Oberlin College. He later made his way to Canada.

Thirty-seven of the rescuers, twenty-five from Oberlin and twelve from Wellington, were indicted in court for violating the Fugitive Slave Act of 1850. The law stated that anyone caught helping escaped slaves could be jailed and fined. A group of the accused held a "Felon Feast" on January 11, 1859, in celebration of the rescue, with music, toasts and speeches criticizing slavery. Later, twenty-one of the indicted were arrested and taken to jail in Cleveland. The rescuers refused to post bond and stayed in jail for months. They used this time as an opportunity to advocate for abolition. Their lawyers made speeches about the horrors of slavery, and two defendants began their own newspaper while in jail—the *Rescuer*—which sold five thousand copies.

Two rescuers, Simeon Bushnell and Charles Langston, were eventually convicted of violating the Fugitive Slave Act. Bushnell received sixty days in jail. Langston's sentence was reduced to twenty days because he sought legal means of freeing Price before resorting to force. Bushnell and Langston filed a writ of habeas corpus with the Ohio Supreme Court, claiming that the law was unconstitutional. On May 24, thousands of people gathered in Cleveland's Public Square to rally in opposition to the law and support of the rescuers. But six days later, the Supreme Court upheld the law with a three to two ruling.

The rescuers were ultimately released on July 6 (except for Bushnell), after Mitchell, Jennings, Lowe and Davis were charged with kidnapping.

HISTORY

OF THE

OBERLIN-WELLINGTON RESCUE.

VIEW OF THE JAIL AT CLEVELAND, OHIO, WHERE THE PRISONERS WERE CONFINED.

COMPILED BY

JACOB R. SHIPHERD.

WITH AN INTRODUCTION BY
PROF. HENRY E. PECK, AND HON. RALPH PLUMB.

BOSTON:
PUBLISHED BY JOHN P. JEWETT AND COMPANY.
CLEVELAND, OHIO:
HENRY P. B. JEWETT.
NEW YORK:
SHELDON AND COMPANY.
1859.

A book was published about the slave rescue that took place in Oberlin and Wellington shortly after the event itself, *History of the Oberlin-Wellington Rescue*, compiled by Jacob R. Shipherd. *Library of Congress.*

Realizing that a jury from Lorain County would likely be sympathetic to the rescuers, the slave catchers agreed to drop the charges on the rescuers if residents would drop the kidnapping charges. The rescuers returned home to a celebration in Oberlin, with speeches from many of those involved. Bushnell was released on July 11, after serving his sentence, to still more celebration. After their release, the rescuers met and created a copy of resolutions: to thank God and everyone who helped them during and after the rescue; to continue to resist the Fugitive Slave Act; to rejoice in the current resistance to the Fugitive Slave Act and encourage fellow Ohioans to continue their protests; and to follow the Word of God by protecting the liberty of all people.

A monument honoring these men exists on East Vine Street in Oberlin. The Wellington hotel where Price was kept no longer exists. On that site (101 Willard Memorial Square) is the Herrick Memorial Library.

A book was written about this shortly after it happened, published in 1859. Its title was *History of the Oberlin-Wellington Rescue*, compiled by Jacob R. Shipherd.

MONTEITH HALL

In 1835, ardent abolitionist Reverend John Monteith built Monteith Hall in Elyria for his family, and this home served as a station on the Underground Railroad. A fifty-foot tunnel ran from his basement to the Black River and allowed slaves to easily reach Lake Erie and escape to Canada. Niches also existed in the walls of the home, allowing escaping fugitives a place to hide when necessary.

Monteith was born on August 5, 1788, in Gettysburg, Pennsylvania, to Daniel Monteith and Sara(h) Lackay (or Lecky or Ledeay); his mother came from Dundee, Scotland. He attended Jefferson College, earning his degree in 1813, and Princeton Theological Seminary, graduating in 1816. A Presbyterian minister, he was asked to spread the Protestant faith in the scarcely populated Detroit, Michigan, in territory that was largely Catholic. He agreed to go for one year, for a salary of at least $800, arriving on horseback on June 25, 1816. He was said to have preached Michigan's first-ever Protestant sermon.

Monteith served as a key force in founding the University of Michigan in 1817 and became the university's first president. In 1837, the school was moved to Ann Arbor, but it originally existed in Detroit. While living there, he married Sara(h) Sophia Granger in June 1820, but she died of a fever that autumn. He then married Abigail Harris on August 30, 1821, and the couple had eight or nine children.

He then left for Clinton, New York, and worked as Hamilton College's chair of ancient languages. In either 1831 or 1832, he moved to Elyria, where he became the new high school's first superintendent. His wife taught there. That's when he became a fervent abolitionist, switching from his belief in gradual elimination of slavery to immediate abolition of the institution.

On December 4, 1833, Monteith attended the American Anti-Slavery Society Convention in Philadelphia as one of the Ohio delegates. He helped to start the Western Reserve Anti-Slavery Society, as well, in 1833. He resigned from work in 1835 to build the three-story Monteith Hall.

That year, he became the president of the Lorain County Anti-Slavery Society. In April, he was elected as a delegate for the Pennsylvania Anti-Slavery Society Convention. From 1837 to 1845, he ran a girls' boarding school from his home, and he served as a conductor of the Underground Railroad.

He died on April 5, 1868. In an 1894 publication, *Commemorative Biographical Records of the Counties of Huron and Lorain, Ohio*, this is a tribute given to him:

Rev. John Monteith was a fine specimen of manly physique; he was six feet tall, straight and muscular, his power of endurance being transmitted from the Scottish race from which he sprang. As a scholar, he was accurate and learned, and though the scope of his culture was not wide, yet in the ancient languages and in French his proficiency was something remarkable for his day. Duty was the mainspring of all his actions, and fearlessly he performed

it, as witness his heroic efforts to introduce the Gospel into undeveloped territories, making long, weary and ofttimes hazardous journeys in the prosecution of benevolent work.

Monteith Hall, located at 218 East Avenue, is currently operated by the Elyria Woman's Club, and it offers guided tours.

LORAIN UNDERGROUND RAILROAD STATION 100 MONUMENT AND REFLECTIVE GARDEN

The city of Lorain was a significant part of the Underground Railroad movement in large part because of its proximity to both Lake Erie and the abolitionist hot spot of Oberlin. In Lorain, the Black River merges with the lake, which created an ideal place to pick up fugitives and take them to safety in Canada. This location is known as Station 100, the last stop before freedom.

On June 16, 2007, a monument was dedicated there, and it features a raised image of an escaping family of slaves. Part of the text was written by author Toni Morrison, who was born and raised in Lorain. It reads, "Both the persecuted and their protectors have hallowed this ground. Our lives and our memories are richer because of their courage."

The Underground Railroad Memorial Garden is attractively landscaped and lit, with two benches provided by the Lorain County Commissioners.

This Ohio Historical Marker commemorates Station 100, the stop along the Underground Railroad located in modern-day Lorain, where fleeing fugitives would get on boats to escape to Canada. *Tracy Isenberg.*

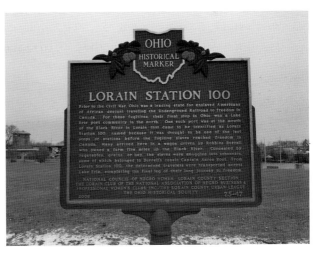

Local civic-minded groups funded this poignant monument, which illustrates how enslaved people often fled to Lorain, where they could get on boats to escape to Canada and find freedom. *Tracy Isenberg.*

There is a small bricked area with pavers listing names of financial supporters and larger polished stone markers of donors who made more significant financial contributions. There is also a historical marker honoring the contributions of Underground Railroad participants located at the Black River Landing at 421 Black River Lane.

Although the identities of the Underground Railroad conductors, including those who steered ships to Canada, are largely unknown, it is believed that Captain Aaron Root transported fugitives to slavery from this spot. Root owned schooners, a key asset in this endeavor, whereas his cousin Robbins Burrell—who lived about five miles away in Sheffield—would find ways to transport escaping slaves to him, perhaps hiding them in his grain house and then transporting them in wagons covered with vegetables, grains and hay. Robbins's brother Jabez Lyman Burrell was an ardent abolitionist living in Oberlin.

Although Robbins was often raided by federal marshals who believed he was breaking the Fugitive Slave Act, they never caught him in any

wrongdoing. In fact, Robbins delighted in inviting them into his house. His home, built in 1820, is still standing. Located at 2752 East River Road in Sheffield Village, it is now owned by the Lorain County Metroparks, and the organization sometimes opens the home for tours and other public events. Jabez Lyman's house also stands. Built in 1852, it is located at 315 College Street in Oberlin and is now the home of the Oberlin College Conservatory's Community Music School. It is referred to as the Burrell-King House.

ADDITIONAL UNDERGROUND RAILROAD STOPS

Kanisa House

A man named Joshua Meyers lived in this compact two-story home. Located at 142 Cleveland Street in Elyria, it served as a Pony Express stagecoach stop. Meyers, who participated in the Underground Railroad, dug a thirty-foot tunnel that began in his basement and led to an open field. He also built small secret spaces in the home where escaping slaves could hide. The structure is now the First Community Interfaith Institute, with public tours available of the Dred Scott Garden, where people can learn about slavery and the Underground Railroad.

Reverend Ansel Clarke Home

Located at 25600 S.R. 58 in Huntington, this was once the home of a Congregational minister who was also an abolitionist who participated on the Underground Railroad. It was said that escaping fugitives could hide in a three-foot space between the bedroom and living room and that trapdoors existed in the attic and in flooring that led to the basement. It is a private home now, not available for tours.

Webster House

Located at 46785 S.R. 18 in Wellington, known as Station 98 of the Underground Railroad, this was the home of David Webster. A makeshift elevator was hidden in his twelve-foot fireplace, so Webster and his son

could lower and raise fugitives to hide them. These slaves often arrived from Ashland (Station 97), and the Websters would take them to Oberlin (Station 99).

PITTSFIELD TOWNSHIP CIVIL WAR MONUMENT

As you drive down Route 58, the Pittsfield Township Civil War monument might attract your attention at the intersection of Route 303, but you may not realize what it has survived. Here's a look back in time at the statue of a single soldier. He stands at rest, with a flag in his left hand.

Citizens of the township passed a two-mill levy in 1895 (assessing a property tax of two dollars per thousand of property value) to build this monument to honor all who had served in the Civil War, including those who died in the war. They debated where to locate this monument, with letters to the editor being written on multiple sides of the issue. The multi-layered twenty-two-foot, four-inch monument was built out of Barre and Quincy granite with a foundation of sandstone. The names of the four battles (all occurring later in the war) in which residents participated are engraved: Atlanta, Chickamauga, Five Forks and Knoxville.

The monument lists the names of the 102 men who fought in the war, with the names of the 21 who died on the South side. Symbols of the four branches of the military are engraved as well, along with the last names of four generals: George Custer, James Garfield, William Tecumseh Sherman and James McPherson. The monument was dedicated on August 13, 1894, during the eighteenth annual reunion of the Soldiers' and Sailors' Association of Lorain County.

On April 11, 1965, Pittsfield was hit by a horrific tornado: "All buildings in the community of Pittsfield were leveled by the tornado and every tree was broken off. About the only thing left standing in the town was a Civil War monument, but even the statue of Gen. Sherman was knocked off its pedestal." (Note: this statue was not actually of Sherman but an anonymous Union soldier.) The figure was replaced after the tornado—but facing the wrong direction. This was rectified and the statue placed as originally constructed.

On October 28, 2009, this monument was approved as a Lorain County Historic Landmark for three reasons: as a monument to the Civil War, as a testament to civic pride and as a structure that survived the 1965 tornado.

This Civil War monument located in Pittsfield commemorates the four battles that men from this township fought in: Atlanta, Chickamauga, Five Forks and Knoxville. *Tracy Isenberg.*

ELYRIA SOLDIER MONUMENT

In the center of town in Ely Square is another Civil War monument, this one designed by sculptor Joseph Carabelli and dedicated on June 26, 1888. Constructed of granite, this monument is dedicated to Elyria's "Heroes Who Fought and Her Martyrs Who Fell that the Republic Might Live: 1861–1865."

Forty-one feet and eight inches in height, the cost was $8,500. A Union Civil War soldier wearing a cape, coat and cap holds a draped flag, with the pole lying at his feet. The base of the monument is column-like with

acanthus and palm leaves at the bottom of the corniced cap. Additional elements include stars, an eagle on a starred shield, a flag and laurel leaves. On the lower part of the monument are two additional life-sized soldiers. The one on the west side is holding the barrel of a rifle with both hands and wearing a knee-length coat. The other soldier's hands rest on top of a sheathed sword. He is also wearing a knee-length coat, along with a brimmed hat and knee-high boots, and has a bushy mustache. Two crossed flags and an anchor decorate the base of the monument, which is surrounded by a fence and located near a water fountain.

This monument honors all of Elyria's Civil War soldiers—and one of them became a general: Charles Carroll Parsons. Born in Elyria in 1838, his father, Jonathan Trumbull, died when Charles was only six months old. Charles's mother, Mary C. Parsons, married the Reverend William Butlin a few years later. Parsons spent much of his time with a favorite uncle. Through the influence of Judge Philemon Bliss, who had lived in Elyria and was then serving in Congress, Parsons was admitted to West Point in 1857, from which he graduated in 1861.

He was commissioned as a first lieutenant and fought at Shiloh; his bravery caused him to be promoted to captain. He took a brief leave of absence to marry Celia Lippett before returning to the war. In Louisville, he commanded an eight-gun battery with two hundred raw recruits. In that battle, his division commander and brigade commander were killed, and forty of his men were killed or wounded. Nearly all the horses had been killed as well, and troops who were supposed to support his battery had retreated. According to *A Standard History of Lorain County, Ohio*: "Still Captain Parsons stood by his guns; his was then truly a one-man battery….A hundred guns were raised to shoot him, but the enemy commander ordered them not to fire, each officer gave the other the military salute, and Captain Parsons walked deliberately away." The next morning, he was said to retrieve part of his battery, and this conduct earned him his next rank: brevet major.

At Stone River, a general called Parsons his "right arm," and he became a lieutenant colonel. Parsons later required surgery, and rather than returning to the front lines, he became an instructor at West Point Military Academy. While there, he met a bishop and decided that he wanted to study theology. Resigning from the army, he took holy orders in 1870, serving as rector of St. Mary's Church of Memphis and then other churches. A yellow plague epidemic hit, and he comforted the sick and the dying, including those who were formerly Confederates. On September 6, 1878, he ultimately succumbed to the disease.

This monument, located in Ely Square, is dedicated to Elyria's "Heroes Who Fought and Her Martyrs Who Fell that the Republic Might Live: 1861–1865." *Tracy Isenberg.*

KIPTON CIVIL WAR MONUMENT

At the intersection of Sixth and State Streets in Kipton is a Civil War statue made of zinc. This metal was typically chosen for statues because of its relatively low cost and ease of workability. Parts of the statue would be individually cast then soldered together, creating a hollow statue. Because the material could be stamped, the monuments could feature more elaborate inscriptions. In Kipton, the statue contains a profile of Abraham Lincoln along with his last name in large lettering, the Grand Army of the Republic emblem, a list of soldiers and a verse from the Coat of Blue poem. All four sides of the statue contain embellishments.

These zinc statues were often made by the Monumental Bronze Company of Bridgeport, Connecticut; the same soldier is used in monuments found in Cardington, Defiance, Grafton, New California, Wauseon, and Windsor.

HUNTINGTON EAGLE MONUMENT

Huntington is located at the southern edge of the county, named after Huntington, Connecticut, from which the settlers originally came. The township was incorporated in August 1822.

At the intersection of State Route 58 and State Route 162, a monument to fallen soldiers was built shortly after the Civil War ended. The design is streamlined, with an eagle-topped obelisk reaching toward the sky. One side has this inscription:

> *In grateful memory of the*
> *volunteers from Huntington*
> *who offered up their lives to*
> *preserve the Federal Union*
> *in the*
> *Great American Rebellion*

The use of the term "Great American Rebellion" is interesting, as that's what some northerners called the war during the years of fighting and for a short time afterward, before the term "Civil War" became common.

The other three sides of this monument are dedicated to listing the names of those who died, along with where and when, as well as a roll of

Huntington residents remembered the men who fought in the Civil War with this monument, its streamlined obelisk topped by an eagle. *Tracy Isenberg.*

A close-up look at the Huntington Civil War monument, built shortly after the war ended. Note the term "Great American Rebellion," which is what some Northerners called the conflict before "Civil War" became common. *Tracy Isenberg.*

honor of others who served and a list of resident soldiers. Places of death range from Shiloh to Savannah, from South Mountain to Antietam, from the Anderson prison to the steamer *General Lyon*—plus some who died at home. Deaths occurred throughout the war, from 1861 to 1865; this wide range of places and dates shows how these dedicated Huntington men fought throughout the war.

LAGRANGE MONUMENT AND PROFILE OF A SOLDIER

Located in the center of town, at the intersection of State Route 301 and 303 in LaGrange, is a Civil War monument topped by a Union soldier statue that was funded by the citizens of the town. Pavers set in a circular fashion surround the memorial, with four brick paths extending to the town square corners. Civil War statues in Union states typically face north—in Confederate states, to the south. But the LaGrange statue faces to the south,

Civil War statues commemorating the Union side typically faced north; the monument in LaGrange, though, faces south, to show that its men didn't turn their backs to the enemy. *Tracy Isenberg.*

indicating how the soldiers didn't turn their backs on the enemy. To add to the story, originally, the statue faced the traditional way before it was decided to make the quirky change. The dedication date is often listed as May 1903, but the *Elyria Reporter* covered the dedication event in May 1904, making that the more likely date.

An Irish immigrant who called LaGrange home enlisted in the Civil War as a private on August 13, 1862. His name was John Smallman, and he was born in Ireland in 1832 to Francis and Eliza Roycroft Smallman. He married a LaGrange woman named Josephine on October 9, 1839, and the couple had two children: Hiram A. (May 28, 1858–March 29, 1939) and Francis Eugene Smallman (August 19, 1860–February 9, 1949).

By the time Smallman enlisted in the war, he had been working as a farmer. He joined the 103rd Ohio Volunteer Infantry, signing up for three years—although he didn't live that long. While fighting in the Battle of Armstrong's Hill south of Knoxville, Tennessee, he was wounded on November 25, 1863. He died on Christmas Eve that same year of those wounds. Here's more about his unit.

103RD OHIO VOLUNTEER INFANTRY

Ask a dozen Lorain County locals what the 103rd OVI is and you'll get at least that many answers. It's a private Civil War museum, right? It's a community of cottages, I think. Oh, I know! That's where we get good pancakes. All of these are true, but the 103rd Ohio Volunteer Infantry Civil War Museum, located at 5501 East Lake Road in Sheffield Lake, is much more, unique in American history.

The 103rd OVI Regiment was formed in 1862 when President Abraham Lincoln asked for volunteers for the struggling Union army. Hundreds of men from Lorain, Cuyahoga and Medina Counties—mostly farmers—signed up, forming the 103rd OVI Regiment. They trained for a brief three weeks before fighting in multiple crucial battles and repelling the deadly Morgan's Raiders from entering Ohio. Although they largely fought in Kentucky and Tennessee, they marched on foot as far away as Atlanta, Georgia, and Raleigh, North Carolina.

The men mustered out in June 1865, two months after Confederate general Robert E. Lee surrendered to Union general Ulysses S. Grant. Rather than scattering to their homes, never to meet again, the survivors

decided to hold annual reunions, first for themselves and then for wives and children as well. In 1867, they formed the 103rd OVI Association, and in 2017, their descendants held the 150th reunion of this association. And even more amazing, the annual reunion now lasts an entire week.

Look Back in Time

At first, reunions of the 103rd Ohio Volunteer Infantry were held throughout the three counties from which the men came, but then they decided they needed a permanent location. Selling stock to raise money, they purchased multiple acres of wooded land along Lake Erie in Sheffield Lake in 1908.

Initially, the men pitched tents on the land during reunions, since the relatively quick dinner had evolved into a weekend-long event. Next, they personally built a mess hall/kitchen/dance hall and then a sixteen-room barracks. Rooms were rented for twenty-five cents per week and could fit a bed or two each. By the 1960s, though, families were attending reunions via RVs and campers or staying in hotels, so the barracks were transformed into a private museum.

Members of the 103rd Ohio Volunteer Infantry unit decided to annually meet for reunions after the Civil War had ended, and their descendants still do today. This is the forty-fourth annual reunion. *Courtesy of the 103rd Ohio Volunteer Infantry Civil War Museum.*

Members of the 103rd Volunteer Infantry gathered together for annual reunions. Here, members who played music posed for a picture. *Courtesy of the 103rd Ohio Volunteer Infantry Civil War Museum.*

Floor one contains Civil War relics and artifacts that, according to museum literature, "have been inherited, collected by, or donated to the descendants of the men of the 103rd Regiment." Floor two houses reunion artifacts, along with a wealth of photographs, historical documents and books. The bookcase itself was built from a fallen walnut tree from the property of an OVI member, with two other members contributing to its construction. The museum is open for tours by appointment, and pancake fundraisers are held four times annually, with free museum tours available on those days. Also on property grounds are twenty-eight homes, each owned by descendants of the 103rd Regiment.

Spotlight on Soldiers

Several men from the 103rd OVI went on to become relatively famous, including Levi T. Scofield. Although he was from Cuyahoga County (Cleveland, near today's intersection of Superior Avenue and East Ninth Street), he is worth a mention, as he designed the imposing Soldiers and Sailors Monument in Cleveland's Public Square, dedicated in 1894 to Cleveland's Civil War heroes. Scofield joined the Union army

Harlan Page Chapman was born in Eaton Township and fought in the Civil War in the 103rd Ohio Volunteer Infantry unit. He survived the war and is buried in Butternut Ridge Cemetery. *Courtesy of the 103rd Ohio Volunteer Infantry Civil War Museum.*

at nineteen, first as a private in the 103rd Regiment, soon commissioned as a second lieutenant. By war's end, Scofield was a captain. And the fourth side of the now-famous Soldiers and Sailors Monument honors the Battle of Resaca, where the 103rd fought on May 14, 1864, in Resaca, Georgia, under the leadership of General William Tecumseh Sherman.

Then there is John Casement, eventually nicknamed General Jack. He was appointed a colonel of the 103rd Regiment, later rose to the rank of brigadier general and, postwar, went on to lay railroad track across the Western Hemisphere. One ingenious innovation: he built boxcars above Union Pacific undercarriages that could be used as kitchens, dining halls, bunkhouses, pantries, offices and/or supply depots and typically carried weaponry in case of attack. His wife, Frances, saw her husband all too seldom, and she also used her time in a way that helped to change history; in 1883, she formed the Equal Rights Association in Painesville, Ohio. For thirty years, she dedicated herself to advocating for women's right to vote.

LAST LIVING VETERAN

The last surviving Civil War veteran in Lorain County was Private Cornelius Quinn. Quinn was born in Cincinnati. On October 30, 1862, he enlisted in the Forty-Eighth Regiment, Ohio Volunteer Infantry, Company D of the Union army. He joined against the will of his mother at the "tender age" of sixteen or seventeen and was the only member of his family to fight for the Union. He was transferred to Company F, 83rd Ohio Volunteer Infantry (January 17, 1865) and then his unit merged with the 48th and the 114th on July 24, 1865, forming the 48th Ohio Battalion. He mustered out of service in May 1866. Quinn served in the army without serious injury and fought

in numerous battles of significance. He sustained only one injury during the war, and it was minor enough for him to keep going.

After the Civil War, Quinn moved to Lorain and became part of a substantial community of Civil War veterans. He enjoyed telling stories about his time as a soldier; during the Battle of Mobile Bay in 1864, Quinn met his uncle, a Confederate soldier, face to face on the battlefield. He also participated in the Lorain Memorial Day parade every year from 1868 to 1939. He got married to Alice, and the two moved to Twentieth Street. Later in life, Quinn acquired two fox terriers named Teak and Brownie, and he trained them to perform at recitals and howl tunes such as "Yankee Doodle."

By the early 1930s, the community of Civil War veterans was dwindling in Lorain, with only a handful of surviving vets. By Memorial Day 1933, only three remained in town: Cornelius Quinn, August Baldwin and Stephan Harris. The three were given seats of honor at the 1933 Memorial Day ceremony. By 1934, only Harris and Quinn were alive to be recognized as guests of honor in the parade and ceremony. Harris passed away in March 1937, leaving Quinn the last remaining Civil War veteran in Lorain County. In an interview with the *Lorain Journal*, he said, "I'm the last one, now, you know. I never see any of the boys anymore, but I think about them a lot." Quinn reunited with other Union veterans in 1938, when he attended the seventy-fifth reunion of Civil War veterans in Gettysburg. There, he met with six other Cincinnati natives who had joined the Union army.

Quinn continued to ride in Lorain's Memorial Day parade in his later years. According to a story in the *Lorain Journal*, Quinn, aged ninety-six, rode in an ambulance during the 1939 Memorial Day parade with Red Cross nurse Pearl S. Murphy. During the parade, he made a "date" with Murphy for next year, promising to attend the 1940 Memorial Day parade. Unfortunately, Quinn passed away on April 8, 1940, less than two months away from his date with the nurse. His obituary cited his death as the result of an illness that kept Quinn confined to his home for around a year. He was survived by his wife, Alice, and niece Esther Fisher. He received a military burial in Elmwood Cemetery, with members of the American Legion Post 30 and Lorain Veterans of the Spanish-American War as pallbearers; they also performed a volley salute.

5

COUNTY MONUMENTS, MARKERS AND PLAQUES

As you drive through Lorain County, you may notice how it is dotted with intriguing historical memorials, markers and plaques. There are so many, in fact, that it would take an entire book to describe them all. This chapter, then, highlights only a small number of them, some that may be brand new to you—along with others you may be aware of, but not know the history behind. Each of them, though, shares an aspect of Lorain County history that clearly deserves more attention.

Many of the historical markers are part of the Ohio Historical Marker program, which began in the 1950s. In fact, there are now more than 1,600 markers throughout the state that share pieces of important and sometimes nearly-forgotten history. About 50 new markers are installed each year, with each one being a partnership between local communities and the Ohio History Connection. More than 30 of these markers exist in Lorain County.

Here are overviews of nine of Lorain County's monuments, markers and plaques.

MEMORIAL ARCH

If you visit Tappan Square in downtown Oberlin, you'll see the Memorial Arch that commemorates Oberlin missionaries and their children—the "Oberlin Band"—who were killed during the 1900 Boxer Rebellion in

Oberlin's Memorial Arch honors the Oberlin Band, the missionaries and their children killed in China's Boxer Rebellion in the Shansi Province. *Tracy Isenberg.*

China's Shansi Province. The monument is located along North Professor Street between West Lorain and College Streets.

This is a magnificent Neoclassical Revival–style structure with bronze tablets listing the names of those lost. The arch's cornerstone was laid on October 16, 1902, and the monument was dedicated seven months later: on May 14, 1903. This was built by the American Board of Commissioners for Foreign Missions using Chicago architect Joseph Lyman Silsbee and dedicated to Oberlin College. The cost: $20,720. D. Willis James donated $20,000, while the rest was collected in small amounts from friends and students of the college.

The Ohio Historic Preservation Office provides a detailed description of the monument, which rises to a height of twenty feet. The base is a half-circle that is bisected with an east–west path that crosses the middle of Tappan Square. The main section is a "rectilinear corridor with a bracketed crown of terraced sandstone and rectangular red marble inlays…flanking colonnades…are single rows of Doric columns set on a curved base."

In the center is engraved "Ye Are Witnesses" to honor the memory of those killed. In 1994, the Oberlin graduates raised money to add two additional plaques that honored the Chinese victims of the Boxer Rebellion.

History Behind Oberlin's Involvement

In 1882, the Congregational Church in Oberlin began sending missionaries to Shansi, where they worked to start schools, provide care for orphans and treat people addicted to opium. Some Chinese, though, resented what they saw as American imperialism and special treatment for Chinese Christians. Anger boiled over, and in the Boxer Rebellion, almost two hundred Western missionaries were massacred, along with more than thirty-two thousand of China's Christians.

In 1908, Oberlin College began an educational exchange program in the Shansi Province, initially supporting educational endeavors in that area of China. In 1918, young Oberlin residents were sent to the Ming Hsien Schools, which served as the foundation of sending Oberlin graduates to Asian universities. Currently, this cultural exchange program, the Oberlin Shansi, helps to send people—usually graduates and other adults—to universities in China, India, Japan and Indonesia, and it is one of the country's oldest educational exchange programs.

The Memorial Arch has been a subject of controversy as well. In past years, college commencement ceremonies have traveled under the arch. This has bothered some students, who have seen the structure as a reminder of American imperialism. Some of them made a statement by bypassing the arch rather than going through it, and college administrators ultimately decided to change the graduation route to one that does not involve walking through the Memorial Arch—although the ceremony still takes place by the memorial.

GENERAL QUINCY ADAMS GILLMORE

The 1989 movie *Glory* was nominated for five Academy Awards and won three, including Best Supporting Actor for Denzel Washington. Other actors involved in the film included Matthew Broderick and Morgan Freeman, and it told the true story of the Fifty-Fourth Massachusetts Volunteer Infantry—one of the first Civil War units almost entirely made up of African American foot soldiers. Many of these men died in heroic fighting at Fort Wagner.

This unit was overseen by General Quincy Adams Gillmore, one of Lorain's native sons—and an Ohio Historical Marker honors him at Lakeview Park, right along Lake Erie. Too few people know about this marker, even though Lakeview Park is filled with crowds of people during the summer

(with steady visitation all year long), because people usually visit for the beach, picnics or festivals—or to see the Lorain lighthouse or the historical rose garden.

The property that is now Lakeview Park once housed Quincy Adams Gillmore's family. His family left Massachusetts and settled in what is now called Lorain in 1810. Born in 1825, he graduated first in his class of 1849 at West Point and chose the military as his career. In 1861, he was part of the Port Royal expedition the Union army took in South Carolina; the expedition ultimately destroyed Fort Pulaski, a fort previously considered virtually indestructible by artillery, in Savannah, Georgia.

In 1863, Gillmore was given command of the Department of the South (South Carolina, Georgia and Florida), which put the Fifty-Fourth Massachusetts Volunteer Infantry under his command. After the men in the unit performed admirably under nearly impossible conditions, the Union army became much more welcoming to African American men who wanted to fight. Gillmore himself became known as one of the most effective military engineers and artillerists of the Civil War.

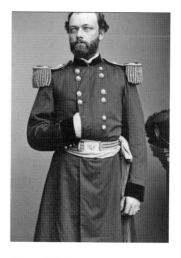

General Quincy Adams Gillmore was born in Lorain, and he commanded the Fifty-Fourth Massachusetts Volunteer Infantry during the Civil War. This unit was the focus of the Academy Award–winning movie *Glory*. *Courtesy of the Quincy Adams Gillmore Civil War Roundtable.*

Gillmore's descendants continued to live in Lorain, with a distant cousin Peggy Gillmore passing away in 2014, shortly before she turned ninety. In 1922, a plaque honoring Gillmore was placed on a boulder and dedicated by the Nathan Perry Chapter of the Daughters of the American Revolution. This memorial erroneously listed his date of birth as 1820. A new, accurate and more detailed monument was dedicated by the City of Lorain, the Lorain County Metroparks (the organization that manages the operations and upkeep of Lakeview Park) and the General Quincy A. Gillmore Civil War Round Table, with participation from other veteran and historical groups, in 2016. A 112-page book was written and compiled by Matthew Weisman and Paula Shorf for the event, *Dedication of the Ohio Historical Marker for General Quincy Adams Gillmore*; it includes contemporary newspaper articles about Gillmore's participation in the Civil War.

EASTER SEALS

Elyria, Ohio, is the birthplace of Easter Seals, an organization that provides services and support to people with disabilities throughout the country. The organization's founder, Edgar F. Allen, was an Elyria businessman whose philanthropic efforts began after a personal tragedy. On Memorial Day 1907, two streetcars collided at the intersection of Fifth Street and Middle Avenue. Eight people were killed in the accident, including Allen's seventeen-year-old son, Homer. The number of casualties was thought to be caused by the local hospital's inadequate resources.

According to the *Elyria Evening Telegram* (October 22, 1908), "Granted the presence of a few trained nurses and a great deal of willing but unexpert help, almost any other house would have served the purpose that the Elyria hospital served last night."

In response to the tragedy, Allen sold his business and began fundraising to build a new hospital. The Elyria Memorial Hospital opened in October 1908, only fifteen months after the streetcar accident. Allen continued his efforts as treasurer of the hospital, where he got inspiration for his next philanthropic project. After observing the lack of treatment options available for children with disabilities, Allen began another fundraising campaign to open the Gates Hospital for Crippled Children, the first hospital in the country to focus exclusively on children with disabilities, in 1915.

Later, he partnered with the Rotary Club of Elyria to found the Ohio Society for Crippled Children on April 22, 1919. With Allen as president, the society grew to become his widest-reaching legacy. As the organization gained members and partnered with Rotary Clubs around the country, it became the National Society for Crippled Children, then the International Society for Crippled Children. In 1967, the organization changed its name to Easter Seals after its most well-known fundraising campaign, one in which donors placed stamp-sized seals on letters and envelopes to show their support. Today, Easter Seals operates through more than 550 sites in the United States and Australia with twenty-three thousand staff members and thousands of volunteers. The organization provides access to services such as medical rehabilitation, home care, therapy and employment placement to more than one million people with disabilities each year.

Three Ohio historical markers in Elyria honor Allen's contributions to the community. A marker was placed on the grounds of the University Hospitals Elyria Medical Center to recognize the birthplace of the Easter Seals Society. In 2012, a memorial park was opened to honor the victims of the

This is one of three memorials that honor Edgar F. Allen, the founder of Easter Seals. This one is by the gates of Ridgelawn Cemetery, where he is buried. *Tracy Isenberg.*

1907 streetcar accident. The park is on the grounds of Elyria High School, near the site of the accident, and contains an Ohio Historical Marker as well as benches, an etched interpretation of the streetcar and eight stones dedicated to the victims of the crash. Later, in 2016, another historical marker honoring Edgar Fiske "Daddy" Allen was placed outside Ridgelawn Cemetery, where Allen is buried along with his wife and son.

At the unveiling of the marker, Mayor Holly C. Brinda said, "It amazes me that when we think back to that day, that tragic day in Elyria, Ohio, where we had probably one of the worst accidents ever, Edgar 'Daddy' Allen took that not only personal tragedy but community tragedy and transformed it into not just one act, but a literal movement."

An original play, *Daddy Allen: The Easter Seals Story*, was commissioned by the Lorain County Metroparks and True North Cultural Arts and performed in 2010. The playwright was Richard O'Donnell.

MYRON T. HERRICK/CHEESE MAKING

During his lifetime, Myron T. Herrick was not involved in the business of cheese making, but an Ohio Historical Marker pairs the two. On a marker at the intersection of Routes 58 and 162 in Huntington, side A highlights the remarkable story of Herrick, who served as the forty-second governor of Ohio from 1904 to 1906. He was considered a friend and confidant to not one president—not two—but three: Presidents William McKinley, William Taft and Warren Harding. In 1912, Herrick was chosen as the ambassador to France, and he served there until 1914, when World War I broke out. He returned to that position in 1921 and continued to serve in that capacity until his death in 1929. He was well loved in France and had the honor of escorting Charles Lindbergh in Paris after Lindbergh completed his groundbreaking transatlantic flight in 1927.

Herrick was born in Huntington Township on October 9, 1854, to Timothy and Mary (Hulbert) Herrick; the family lived there until he was twelve. Because his family was not wealthy, he needed to work at a young age but continued to attend school, including Oberlin College for a while. Moving to St. Louis, Missouri, he taught school and worked as a journalist, saving his money. Once he had several hundred dollars, he returned to Ohio, where he spent two years studying at Ohio Wesleyan University before studying law in Cleveland. Admitted to the bar in 1878, he began practicing law in Cleveland.

Herrick also became involved in business, becoming the director of the Euclid Avenue National Bank and then the secretary/treasurer and then the president of the Society for Savings Bank. Because of his financial and legal influence, he partnered with other investors to expand railroads in the state and throughout the country. His success also captured the attention of well-connected Republicans.

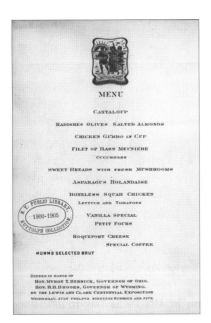

Myron Herrick from Wellington served as Ohio's forty-second governor from 1904 to 1906. This is a menu from a special event held on July 12, 1905. *Courtesy of the New York Public Library Digital Collections.*

In 1885, Herrick was elected to Cleveland's city council, serving through 1888, and he began to gain prominence in statewide politics by serving as a delegate to the Republican National Convention in 1888, 1892, 1896, 1900, 1904 and 1908. In 1903, he ran for governor against Progressive reformer Tom L. Johnson, winning by more than 113,000 votes. After losing his reelection bid, he returned to Cleveland and refused two offers to serve as the U.S. ambassador to Italy made by McKinley and President Theodore Roosevelt before accepting William Taft's offer of an ambassadorship in France in 1912. On August 10, 1915, at a community celebration in Huntington, Herrick gave a speech, saying that "modern modes of travel had made of the world a neighborhood and that it was up to us to make it a brotherhood."

Although Herrick's French ambassadorship duties technically existed before and after the war, with a break in between, he continued to serve France unofficially during the war and was awarded the French Legion of Honor cross in gratitude for his service. He officially returned to that position after his Senate bid was not successful in 1920; fortunately, his efforts in strengthening French and American diplomatic ties during his second tenure as ambassador were quite successful. Herrick died in France on March 31, 1929, at the age of seventy-four.

On the B side of Herrick's monument is a tribute to the Horr Cheese House of 1865. Throughout history, cheese making had largely been handled in people's homes, and that remained true through the Civil War era in Ohio. In 1865, however, two brothers named C.W. and J.C. Horr, both farmers, researched new methods of cheese making and investigated whether they could count on a steady milk supply from other farmers in the area. When satisfied that they could, they built a cheese factory in Huntington Township; they were so successful that numerous other farmers and cheese makers decided to do the same. By 1878, there were more than forty cheese operations in Lorain County, with the Cleveland, Columbus and Cincinnati Railroad in Wellington making it efficient to ship the cheese nationally. This earned Wellington the nickname of the Cheese Empire of the Nation.

According to the *History of Lorain County, Ohio*, published in 1879, the amount of cheese shipped from Wellington in 1878 was "six million four hundred and sixty-five thousand six hundred and seventy-four pounds." The book also stated that R.A. Horr traveled to Europe to set up shipping arrangements to Liverpool, England, and Glasgow, Scotland; at that time, thousands of men in and around Wellington were involved in dairy-related production, including cheese and butter.

A man named Edward F. Webster joined the Horrs' cheese factory after returning to Lorain County after the Civil War ended. Webster enlisted as a private on August 26, 1861, in Company H of the Second Regiment of Ohio Calvary. He received numerous promotions, including to corporal, sergeant and lieutenant, then chief ordnance officer, so it was not surprising that he had the level of organizational skills needed for a highly successful cheese-making company. In 1897, after various reorganizations and name changes, Webster was named president of the Horr-Warner Company.

It should be noted that the Wellington marker also honors Reverend Ansel Clarke, a Congregationalist minister who participated in the Underground Railroad. There is no connection between the three stories on the marker, other than they all occurred in the same township. The township officials simply figured it made sense to frugally take advantage of all available marker space.

NORTON STRANGE TOWNSHEND, MD

Norton S. Townshend made significant contributions to society, as he worked as a "progressive farmer, physician and legislator." He served in the Ohio House of Representatives in 1848–49 and was a delegate to the State Constitutional Convention, a United States Congressman from 1851 to 1853 and a member of the Ohio State Senate in 1854–55. As a congressman, his politics were progressive, his focus on preventing the expansion of slavery into the country's western territories. He belonged to the Free Soil Party, which advocated for civil rights for women and free black people, and became known for his suffrage beliefs, also believing that women should have the ability to hold and dispose of property in a way that was equal to rights that were held by white men. He also served in the Civil War as a medical inspector with a rank of lieutenant colonel (1863–65).

Townshend played a key role in the creation of the Ohio Agricultural and Mechanical College in Columbus and continued his association with the college, both as a founding board member and as the first professor of agriculture. In 1878, this college became the Ohio State University; Townshend Hall, the agricultural building, was named after him because of his significant contributions.

Townshend was born in Clay-Coaton, Northamptonshire, England, on Christmas Day 1815, and his family moved to Avon, Ohio, in 1830. His

father purchased 150 acres of land, and they quickly doubled their acreage. An innovative family, they installed tile drains in their fields, probably the first to do so, and land productivity increased. He was said to educate himself through reading his father's library and briefly taught school. At age twenty-three, he mentored with an Elyria doctor, then enrolled in the Cincinnati Medical College in 1837. In 1840, he graduated from the College of Physicians and Surgeons in New York and studied medicine internationally, including in London, Paris, Edinburgh and Dublin hospitals. By 1841, he was back in the Avon area, where he briefly practiced medicine and married Harriet Wood in 1843.

He also developed a long-term relationship with the abolitionist attorney Salmon Chase, who was a key developer of the Underground Railroad. Chase and Townshend supported the Free Soil Party and the political party's motto of "Free Soil, Free Labor, Free Men." He was said to hold considerable power, politically, and worked to repeal what were known as the Black Laws. These laws were passed in 1804 and 1807 to discourage African Americans from migrating to Ohio, in part because citizens were concerned about the economic impact of this influx.

These laws required black people to prove they were not slaves. They also needed to have at least two people pay a surety bond of $500 to ensure they would behave appropriately. Limits were placed on their ability to marry white people and to own guns, among other restrictions. Townshend's efforts played a significant role in getting these laws partially repealed in 1849. He and the other Free Soil legislator, John F. Morse, negotiated with Ohio Democrats to support this repeal; in turn, Townshend and Morse would support Democratic candidates for the state legislature.

Townshend and Morse also played a key role in getting Salmon Chase elected as Ohio's twenty-third governor in 1855, the state's first Republican one. Chase went on to become a U.S. senator and Supreme Court chief justice. Townshend and Morse used their influence to get additional antislavery men into important roles in Ohio. Townshend served as a member of the 1851 constitutional convention, much to the dismay of politicians from southern states. In 1853, he was elected to the state senate, but his political career ended in 1855, a year after his wife died. He then married Margaret Bailey from Clarksburg, Virginia.

Townshend was elected to the State Board of Agriculture, working hard to advocate for the Morrill Land Grant Act, which passed in 1862. This act allowed eligible states to receive thirty thousand acres of federal land per

senator and representative, with proceeds of land sales to be used to create and fund institutes of higher education.

Townshend then served in the Civil War as a lieutenant colonel medical inspector; after the war, he returned his attention to academia. He died on July 13, 1895, in Columbus but is buried in Avon's Mound Cemetery at the corner of Route 83 and Detroit Road. The plaque honoring him is by Avon Town Hall.

TERRIBLE FISH

Around 1867, a hotel owner named Jay Terrell and his son were walking along Lake Erie in Sheffield Lake, and they found fossils of what must have been a "terrible fish." It was a "massive arthrodire," which is an extinct joint-necked, armor-plated, sheared-jawed fish that lived 354 to 364 million years ago. It lived in the shallow waters of the Devonian Sea, which covered a great portion of the eastern part of today's North America, including Ohio, and this creature was "clearly the top marine predator in the Devonian Period (the 'Age of Fishes')."

This fish would have measured at least sixteen to twenty feet in length, possibly more, and weighed an astonishing six thousand pounds (possibly more!), king of the food chain. Interestingly enough, this predator would have fought with the ancestors of the great white. This creature's jaws have been described as "bladelike," its teeth having a razor sharpness. Computer simulations have determined that its bite strength approximated eight thousand pounds per square inch of cutting edge. In comparison, today's large dogs have bite strength of only a few hundred pounds.

Its protective armor plating consisted of interlocking plates of bone that were extremely dense and covered the head and neck area. Despite the weight, it was believed to have been able to swiftly move through the waters in search of prey. According to the Cleveland Museum of Natural History, this fish "was capable of chopping prehistoric sharks into chum!"

Statistically speaking, more remains are found of predators, such as this one, than prey. This is because predator bones are heavier and larger, making them easier to spot and more likely to have been well preserved. This specimen, and others like it, are even more well preserved than what's typical for predator fossils. That's because, for a reason not yet fully understood, the shale found in northeast Ohio preserves prehistoric remains especially well.

Typically, the only hard matter found in most fossils is teeth, but the shale in northeast Ohio has even preserved the soft tissue of creatures.

This outcrop of shale exists along the lakeshore in Lorain County, sometimes running several hundred feet deep. The shale contains sediment from deep waters, sediment with exceptionally fine particles, along with marine fossils (plant and animal alike). At one point in time, a professor named A.A. Wright studied specimens of this Lorain County shale and discovered that 10 to 20 percent of the material was, in fact, carbon in nature, "consisting in part of the spores of algae such as float around in the Sargasso Sea in the Atlantic." When dated, Lorain County shale is comparable to the Old Red Sandstone shale in Scotland, where fossils of plated fish, dubbed *Pteriehthys*, were found.

This fish was named the *Dinichthys Terrelli* in Terrell's honor and is now known as the *Dunkleosteus terrelli*—or "Dunk" for short. The revised name also honors a former museum curator of vertebrate paleontology, Dr. David Dunkle, who also found early fossils of this monstrous-sized fish. This fearsome creature has been featured on two different Animal Planet shows: *Animal Armageddon* and *River Monsters*.

The marker honoring this fish is located in Shell Cover Park on Lake Road in Sheffield Lake.

As a side note, specimens found in shale in nearby Berea in Cuyahoga County included the skeleton of a shark that, in its stomach, contained bones and scales of fish of a type never uncovered before. It was displayed in the British Museum in London along with fossils from Lorain County.

GREAT KIPTON TRAIN WRECK

If you've ever heard the phrase "get on the ball," then you may have been affected by a piece of Kipton history. Lake Shore and Michigan Southern Railway Company tracks ran through town, and on April 18, 1891, an eastbound and a westbound train collided, resulting in nine fatalities and heavy depot damage.

This collision occurred between a mail train (no. 14) heading east at rapid speed and the Toledo Express passenger train heading west from Elyria. The passenger train should have pulled over to a siding to allow the mail train to pass, but because its conductor's watch had stopped for four minutes after being dropped into a mud puddle, its timing was off, and the passenger train

arrived late to its stopping point. The conductor was not aware of this time stoppage until the wreck was investigated. The train station and a row of freight cars may have impaired the mail train engineer's line of vision. In any case, by the time he applied his brakes, the train could not stop in time.

The Smithsonian's National Postal Museum blog quotes the *Atlanta Constitution*:

> *The engine of the Toledo express was knocked squarely across the track, and that of the fast mail reared in the air, resting on the top of the other. The fast mail consisted of three mail cars and two parlor cars, and the Toledo express of five coaches and two baggage cars. The first and second mail cars were telescoped and smashed to kindling wood, and the third crashed into the first two and rolled over on the station platform, breaking the windows of the building.*

Six railway mail service clerks were killed, all from Ohio: "Frank Nugent of Toledo, J.L. Clement of Cleveland, James McKinley of Conneaut, and Charles Hammil, John J. Bowerfield, and Charles L. McDowell, all of Elyria." Also killed were two engineers and one firefighter.

This accident caused newspapers across the country to write articles about the dangers of working as a mail clerk on the railroad system. The post office would highlight this wreck when repeating its request to railway companies to build their mail cars out of steel, rather than wood (as was the case at the time).

To try to prevent this from happening again, Cleveland-area jeweler Webb C. Ball was hired to audit watch conditions through this company's railway lines. Ball was known for his attention to detail, and his prompt nature led to people telling others to "get on the ball." (It's important to note that other alternative explanations of this phrase, including ones associated with baseball, have also been proposed.)

Ball created a timekeeping system for the railway to help prevent additional accidents. This became the basis for the watch performance and inspection standards, established in 1893, and Ball himself became the timekeeper for the railroad system. He meticulously monitored how his company made watches for the railway employees, how often they were tested and inspected and how accurate they were. Standards stated that the watches must be accurate to thirty seconds per week, and watch faces were made of white to make them more visible. Clock times and faces at the stations were also standardized, and time was synchronized via telegraph-relayed verifications.

Railroad regulations continued to mandate Ball-manufactured watches for employees through the 1970s. In 2016, on the 125th anniversary of the crash, a local historian named Adam Matthews talked to Elyria's *Chronicle Telegram* about owning an original Ball watch crafted in the early 1900s. This solid-gold watch was a college graduation gift from his parents and is still working today. Matthews asserted that his watch is more accurate than today's digital versions.

A marker commemorating the train wreck is located at Kipton's Railway Depot between the Kipton Community Park and Rosa Street. The train station is no longer in existence, although evidence of the brick foundation is near the marker; the tracks have been replaced by the Northcoast Inland Trail. The marker lists eight fatalities, not nine; a likely explanation is that the firefighter was not included in that figure. The date is off by one day, too, given as April 19.

PETER MILLER HOUSE

If you've ever read a McGuffy Reader, a staple of children's education starting in the mid-nineteenth century, perhaps you'll recall a story of a young man walking home through a swamp, then being chased up a tree by a bear. As the man desperately climbs up the tree, the bear's fearsome jaws snap at his shoes. Three times the bear tries to reach the man before the duo crashes to the ground. The man runs, reaching home safely after the bear gives up the hunt. That story appeared in the 1844 edition of William McGuffy's Second Reader and is believed to be a true story from the life of Peter J. Miller.

The Peter Miller House is a Greek Revival home in Avon Lake built in 1830 and still standing, one of the last pre–Civil War houses still existing in Lorain County's lakefront. In fact, Peter's parents, Adam and Anna (Teamount) Miller, were some of Avon Lake's first permanent nonnative settlers, moving from New York in 1819. One account states that they had ten children; the oldest child on record was named Alexis, with Peter being the youngest. The family arrived at the wilderness that is today Avon Lake and built a log cabin. On April 17, 1827, Adam deeded the property to Peter, who married Ruth Houseworth on January 3, 1828. In 1830, they built a frame house on the property, one of the first two on Avon Township's lakeshore. The couple had five known children: John A., Amanda, Glover, Julia and Jennette.

Peter died in 1851, but his family continued to reside on the property, it is believed, until 1925. Members of the family still owned the property after 1925, renting it out until they sold it in 1960. The City of Avon Lake bought the property in 1962, restoring the home whenever funds were available. It has been operated as a museum since September 1989, with volunteer trustees overseeing the operation. The first floor of the home is open for tours.

The furnished home has two original front doors. The front room is the parlor, once used for special occasions, and features an 1885 E.P. Carpenter pump organ along with other nineteenth-century furnishings. Other first-floor rooms include a small bedroom also used as a birthing room, a keeping room and another bedroom, one that contains an 1850s Jenny Lind headboard rope bed. The pantry contains an 1840s walking wheel, which is a spinning wheel that required the operator to walk back and forth, and the annex features pictures, maps and genealogy information. The root cellar houses special programs and meetings, and the basement also contains period displays. A marker shares the story of the house located at 33740 Lake Road in Avon Lake.

ADMIRAL KING MONUMENT/ERIC BARNES WALKWAY/SETTLERS' WATCH

Just south of First Street in Lorain, on city-owned property on Hamilton Avenue, a green space and memorial honors Admiral Ernest J. King, the man who commanded the U.S. Navy in one of the most crucial times in recent history: World War II. He is the only officer to ever hold these two prominent positions: commander in chief of the U.S. Navy and the chief of naval operations. This memorialized green space is located directly across from King's birthplace, a home still privately owned and occupied. The home, now more than 140 years old, is located less than one hundred yards from Lake Erie. Surely the call of these blue waters led King to his love of the navy.

The flagpole placed in the center of the green space was recycled from the American Ship Building Company, formerly located in Lorain; numerous ships, including the USS *Lorain*, were launched from that site during World War II. The U.S. flag flies on this pole, along with Ohio's state flag and the U.S. Navy Ensign. Plus, naval code flags spell out KING. The flags are lit by solar power.

This green space honors Admiral Ernest J. King, the man who commanded the U.S. Navy during World War II. It is in Lorain, right by where he was born and raised. *Tracy Isenberg.*

Ornamental landscaping is shaped like an anchor, and an anchor came from the former Admiral King High School. The historical marker announcing that this is a Lorain County Historical Site is placed next to a bench made from recycled materials.

King was born in Lorain on November 23, 1878, and a comprehensive look at his life and accomplishments would take a book, but here is an overview of his success in the *Houghton Mifflin Companion to US History*:

> *Most naval historians agree that King was the greatest naval commander of the twentieth century. His powers of reason were first-rate, and his professionalism and understanding of the complexities of modern warfare were without parallel. Although he was too unrestrained a personality to succeed as a military diplomat, he was intelligent, dynamic, and merciless, widely respected for exacting outstanding results from his ships and his men. He was also feared and hated, but his grasp of strategy and his ability to impose his will on the enemy were major factors in the defeat of the Axis navies in World War II.*

In Lorain's Settlers' Watch, wooden carvings represent important aspects of the city. This eagle honors U.S. Air Force airman Eric M. Barnes, a Lorainite who gave his all during the Iraq War. *Tracy Isenberg.*

Connected to the green space honoring King in a southwest direction is the Eric Barnes Walkway. Lorainite Airman First Class Eric Barnes was a graduate of Admiral King High School who was killed while serving in Iraq. The walkway honors him, along with four other Lorain military sons who died in Afghanistan or Iraq, and the walkway was named after Barnes because it connects a hero of yesterday—Admiral King—to modern-day heroes such as Barnes. The other men honored are Marine Lance Corporal Joseph Giese, Marine Lance Corporal David R. Hall, Army Sergeant Bruce Horner and Army Sergeant Louis Torres.

On the opposite side of the walkway is Settlers' Watch, where former tree stumps were transformed into intricate carvings with historical meaning to Lorainites: a ship captain at his wheel, the Lorain Lighthouse (which can be seen in the waters of Lake Erie while standing in these memorial areas) and more. Walkway bricks come from the former Lorain High School, from which Admiral King graduated.

In Lakeview Park, an obelisk dedicated by King in August 1942 honors the men and women of Lorain who fought in the world wars.

6

LITERARY LORAIN

People often associate Lorain with industry and manufacturing, with Lake Erie, the Lorain Lighthouse and the International Festival—and for good reason.

Here's something less known: Lorain is a literary powerhouse with nationally and even internationally known writers who were born and/or raised there. It is fitting, then, that the Lorain Historical Society is housed in what was once a Carnegie library.

The story of Andrew Carnegie reads like a rags-to-riches tale. His family—often described as "dirt poor"—immigrated to the United States from Scotland. By the 1880s, he was the extraordinarily wealthy head of a steel empire, and then he basically gave his wealth away, providing $60 million to fund 1,689 public libraries around the United States. This mind-boggling gift transformed the concept of libraries from being subscription-based and only available to other wealthy people to something accessible to the entire community. NPR describes the Carnegie libraries as "temples of learning, ambition, aspiration for towns and cities throughout the United States."

In Ohio, 111 Carnegie libraries were built, according to the author of *Carnegie Libraries of Ohio: Our Cultural Heritage*, with multiple examples in Lorain County. One, located in Amherst, is still used as a public library; another houses the administrative offices at Oberlin College. Lorain's building is unusual in that it's two stories, rare for Carnegie libraries in Ohio.

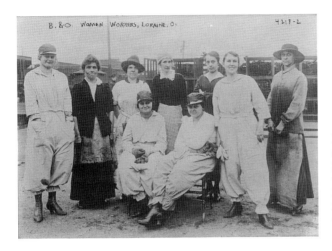

Lorain is well known for its industry. Less well known are the women who worked these jobs. Here are women ready for a hard day's work at the B&O Railroad in 1903. *Library of Congress.*

The Lorain Lighthouse was built in 1917 and is known as the Jewel of the Port. Although it is decommissioned, tours of the structure are regularly scheduled. *Courtesy of the Lorain Historical Society.*

Prior to Carnegie's generosity, Lorain residents struggled to build a library system. In 1883, a subscription-based library started. Between that time and 1900, citizens tried multiple times to get a public library started, but their efforts failed. In 1900, several men from First Congregational Church collaborated with women's literary clubs and charitable groups to create a small library. In 1901, they formed the Lorain Public Library Association.

Around 1902, a group of Lorain residents approached steel magnate Andrew Carnegie to fund their first public library. He donated $30,000, and this library was the result. *Courtesy of the Lorain Historical Society.*

By this time, 520 books were available for patrons. The group approached Andrew Carnegie, and he agreed to provide $30,000 if a suitable location was found and if the city agreed to fund the library with $3,000 per year. The group chose the corner of Streator Park for the location, off Tenth Street. This property was donated to the city in 1895 by Dr. Worthy S. Streator with the following restrictions: it must be used as parkland, a library or city hall. The Streator Park Carnegie Library project was approved in 1902, with the cornerstone laid on August 19, 1903.

When the cornerstone was laid, head librarian Margaret Deming's remarks included the following:

> *It is no mistaken enthusiasm that says that today, that witnesses the laying of the cornerstone of the beautiful building which is to be the home of the Lorain Public Library is one of the greatest days in the history of the town…to open the doors to that elect society which is the privilege of us all to enjoy when we read good books.*

On opening day— May 20, 1904—this red brick and limestone building housed 3,240 items, including a selection of technical and industrial books for men working in factories. The library served the community well, but by 1940, more space was needed. In the 1950s, the Lorain Public Library

bought property on Sixth Street to build a new structure, which opened on November 23, 1957. Since that date, the Carnegie building has not been part of the library system.

In the 1960s, the building became a civil defense shelter. In 1970, renovations took place so that the building could become the Lorain Parks and Recreation offices; this lasted until 2008. The building lay vacant until August 2013, which is when it became the home of the Lorain Historical Society.

HELEN STEINER RICE

Helen Elaine Steiner Rice may be one of the most prolific poets ever in the United States, with approximately seventy-five books of her poetry published. This doesn't count the large numbers of poems that she wrote as the editor of verse at Gibson Arts Company in Cincinnati, Ohio, with her verses later purchased by the American Greeting Card Company upon Gibson's dissolution. When Helen's life was over, she was a millionaire, and her established trust fund continues to supply churches and organizations with grant funding.

Helen Steiner was born in Lorain on May 19, 1900, to John and Anna Steiner. Her only sibling, Gertrude, was born two years later. Helen's birthplace in Lorain still currently exists, but it is slated for demolition due to its deteriorated condition. John Steiner worked at the Baltimore & Ohio Railway, and the family worshipped at the former Twentieth Street Methodist Church. Helen attended Garden Avenue School, Garfield School and Lorain High School, where she graduated in 1918. She was an intelligent child and dreamed of earning her liberal arts degree from Ohio Wesleyan University, then attending Ohio State University for a degree in law, but circumstances did not allow this to happen. Helen Steiner also dreamed of becoming a congresswoman—an astonishing goal, since women didn't yet have the right to vote.

After graduating from high school, she got a job at Lorain Electric and Light Power Company to earn extra money for herself and her family. But when her father died a few months later after contracting the Spanish influenza during the worldwide pandemic, Steiner needed to stay at her job to support her mother and her sister. At this point, Gertrude was still in school. Helen worked at the Lorain Electric and Light Power Company for nine years and was eventually promoted to advertising manager because

of her poems and talent for window decorations. During these years, Steiner built her reputation as a businesswoman and a public speaker. She gave speeches around the country about public service and women in the workforce. In 1927, she quit her job to start her own public speaking business, Steiner Service.

Helen became known as a feminist, as she spoke out about the importance of hiring more women. In one interview, she stated that "women should be partners in the workplace, not merely a decoration." She also noted, "Women's rights were a constant topic while I was growing up. All of my teachers had been suffragettes, and I firmly believed in the right and ability of women to win their own way in the world."

Steiner's public speaking career flourished, allowing her to provide her family with financial stability. She was even invited to the White House, where she was photographed with President Calvin Coolidge. And when she was asked to speak at the Dayton Savings and Trust Company in Dayton, Ohio, her life changed forever. She was paid $150 plus expenses (comparable to more than $2,000 plus expenses today!), and she met the company's vice president, a man named Franklin Rice. Helen told Franklin that everywhere she went, her picture ended up in the newspaper on the front page. When it appeared in Dayton's paper, just as she predicted, Rice drove up to Lorain to show the article to her. The two married on January 30, 1929, and honeymooned in the Caribbean before moving into a fourteen-room home in Dayton, where they owned three luxury cars.

Their luck changed only months later when the stock market crashed. Franklin lost his job, and most of their wealth was lost in the stock market plunge. Two years later, Helen managed to secure a full-time job as a troubleshooter for the Gibson Art Company, a successful greeting card business. Though her position was beneficial for the Rices' financial problems, Franklin grew depressed about their debts and the fact that he could not support the family. Beyond despondent, he committed suicide on October 14, 1932.

After Franklin's death, Helen needed to earn more money to pay off their debts. Luckily, she was soon promoted to editor of verse at Gibson. Her verses quickly became so popular that her name was attached to the greeting cards using her verses, which was and still is unusual. By 1940, she was considered one of the best poets in the industry.

In 1960, her poems gained even wider fame when her verse "The Priceless Gift of Christmas" was read on *The Lawrence Welk Show*. The poem was a hit, and soon she was asked if she could supply more verses for the show.

Her poem "The Praying Hands" was read on the show in 1962, and as a result, it became one of the most popular greeting cards ever produced. Even today, it remains a favorite of many. When President John F. Kennedy was assassinated in 1963, Welk asked Steiner Rice to write a tribute to him, and this was also featured on the national show.

After her achievement of national fame, Helen was approached about publishing hardcover books of her poems. Her first book, *Just for You: A Special Collection of Inspirational Verses*, was published in 1967. She published nine more books during her lifetime. In 1971, Helen retired from her position at Gibson but remained a consultant to the company.

Shortly before her death, one of Steiner Rice's earliest dreams came true. After working to support her family, marrying, then writing to support herself, she had long given up her hopes of earning a college degree. But on March 14, 1981, the president of Mt. St. Joseph College awarded Helen an honorary doctorate of humane letters. Only a month later, on April 23, Steiner Rice passed away at the age of eighty.

Helen is buried in Lorain's Elmwood Cemetery next to her parents. In 1983, the Praying Hands memorial was constructed in her memory at Lorain's Ridge Hill Cemetery. In 2002, the state of Ohio dedicated a bicentennial marker in her honor at Lakeview Park in Lorain, procured under the leadership of the Friends of Helen Steiner Rice. On October 14, 2007, she was inducted into the Ohio State National Hall of Fame. Also because of the Friends of Helen Steiner Rice, a Lorain group established to get Helen honored in her hometown, a new elementary school on Tacoma Avenue was named Helen Steiner Rice Elementary School. There is a Helen Steiner Rice Foundation, managed in Lorain County, which awards grant funding to those in need in both Hamilton and Lorain Counties.

In 1999, Lorainite Hilaire Tavenner played a key role in establishing the Friends of Helen Steiner Rice, which, eight years later, morphed into the International Writers Association (IWA). IWA is based in Lorain, Ohio, but has members in about eight other countries. This group is also a founding sponsor of the Northeast Ohio Christian Writer's Association. On May 17, 2015, IWA partnered with Lorain County Community College to celebrate the 115th anniversary of Steiner Rice's birth. Charlene Savoca has frequently portrayed Helen Steiner Rice at a variety of locations and events, including at the Lorain Historical Society's Celebrate Literary Lorain Week in October 2017.

Toni Morrison

Perhaps the most famous Lorain writer is Toni Morrison, the first African American woman to be awarded the Nobel Prize for Literature—she also won a Pulitzer Prize. Born on February 18, 1931, as Chloe Anthony Wofford, she was the second of four children of George Wofford, a welder, and Ramah, a domestic worker. Morrison was born during the Great Depression, and her father worked multiple jobs to support his growing family.

Ramah's parents, Ardelia and John Solomon Willis, were from Greenville, Alabama, but decided to leave around 1910. Deeply in debt, they'd lost their farm and wanted a fresh start. Morrison's paternal grandparents left Georgia because of violence against African Americans in the South at the time and because they wanted something better than sharecropping, in which people would work on someone else's farm and owe the property owner a significant portion of the crops. All these ancestors of Morrison's chose to settle in Lorain.

She later told a *New York Times* reporter that she was the only child in her first grade who could read. Morrison's childhood, it has been said, was brimming with "African American folklore, music, rituals, and myths." Family members told stories to one another, and Morrison has noted that her writing fulfills a similar function, serving as reminders of where we've been and where our places are in the community. She has also said that her childhood memories serve as jumpstarts to her writing, and her first novel, *The Bluest Eye*, was set in Lorain. Phrases such as "quiet as it's kept" were used by women in her childhood and signaled the coming of gossip—often of dubious origin.

As Morrison grew up in Lorain, she continued to take her studies seriously, and reading became a passion. While attending Lorain High School (the original Lorain High School located on Sixth Street where the Admiral King Elementary School currently exists), she particularly enjoyed reading Jane Austen, Leo Tolstoy, Gustave Flaubert and other authors who used specificity in their writing. This later inspired her to use her knowledge of the African American culture to write her own novels.

Morrison worked at the Carnegie library on Tenth Street and Streator Place (now the home of the Lorain Historical Society). Surely, Morrison's time working in the library only increased her love of reading and the amount of reading material she absorbed. When she completed high school in 1949, she graduated with honors.

She then left Lorain to study English at Howard University in Washington, D.C. She began being called Toni because people there struggled to properly pronounce Chloe. After receiving a bachelor of arts degree in English in 1953, she earned a master's degree in English from Cornell University. She taught at Texas Southern University in Houston for two years before teaching at her alma mater, Howard University. She married Harold Morrison, a Jamaican architect who taught with her, in 1958. The couple had two sons, Harold "Ford" and Slade, but divorced in 1964. Morrison then moved to New York, where she worked as an editor for Random House—and she began writing her novels in the evenings. *The Bluest Eye* was published in 1970. Additional novels include *Sula* (1974), *Song of Solomon* (1977), *Tar Baby* (1981), *Beloved* (1987), *Jazz* (1992) and *Paradise* (1997). Her first children's book, *The Big Box*, was published in 1999.

Although Morrison never lived in Lorain after finishing high school, she has returned multiple times. In 1995, the main branch of the Lorain Public Library dedicated the Toni Morrison Reading Room, and although it was uncertain whether she would attend, she did. While there, she was not necessarily expected to speak, but she did. She said that as she looked out at those in attendance, she wanted to take a picture. As she traveled the world and lived in different places, she tried to share what growing up in Lorain was like. The audience in 1995 consisted of people of different races, cultures and socioeconomic backgrounds sitting together, and this, Morrison exclaimed, this is what her hometown is like.

In 2009, she returned to Oberlin to dedicate a steel bench and deliver a lecture in Finney Chapel. The bench exists at the intersection of North Main and Lorain Streets and commemorates Oberlin's crucial role in the Underground Railroad. During the dedication, she was quoted as saying that Oberlin was an ideal place for this bench because of the understanding that exists of the relationship between blacks and white.

> *It wasn't only that the black ex, former, and escaped slaves made their way out with the help of other former slaves, it was that they arrived at a place where outraged white people…white people outraged at slavery were there to offer them succor and to offer them hope and to provide them escape. So that combination of commitment on the part of Americans is what's significant about Oberlin, Oberlin in particular.*

Her awards are too numerous to detail, but here are a couple more. In 2000, President Bill Clinton presented her with the National Humanities

Medal. The president said that Morrison had "entered America's heart." In 2016, she received a lifetime achievement award from PEN America.

The Toni Morrison Elementary School is located on Fortieth Street in Lorain.

BORN IN THE 1940S

During the 1940s, multiple people were born in Lorain (or, in one case, born in Ashtabula, Ohio, and then moved to Lorain) who went on to have stellar writing careers. Here are four of them.

Michael Dirda

Pulitzer Prize winner Michael Dirda was born in Lorain, Ohio, on November 8, 1948. Dirda spent most of his young life in Lorain, living with his parents, Christine and Michael Dirda, on West Twenty-Ninth Street and attending Lorain public schools. After graduating from Admiral King High School in 1966, Dirda enrolled in Oberlin College to pursue a bachelor's degree in English, starting a lifetime of literary study. After graduating magna cum laude, Dirda traveled to Marseille, France, on a Fulbright grant to teach English. He later earned his MA and PhD in comparative literature from Cornell University and taught world literature at American University and George Mason University.

Dirda gained his high reputation in the world of literature as a critic and literary journalist for the *Washington Post*'s Book World. His reviews and essays have appeared in the *Washington Post* since 1978 and often focus on new, innovative works of fiction and poetry or rediscovering forgotten works from the past. Dirda has also contributed to the *Smithsonian Magazine, Review of Contemporary Fiction* and *Chronicle of Higher Education*. He has published numerous books of his own, including *Book by Book: Notes on Reading and Life; Classics for Pleasure;* and *Browsings: A Year of Reading, Collecting, and Living with Books. An Open Book: Coming of Age in the Heartland* was published in 2003 and shares his experiences growing up in Lorain. People familiar with Lorain will recognize numerous places he describes. In 1993, Dirda received the Pulitzer Prize for Distinguished Criticism.

Don Novello

Don Novello is a stand-up comedian best known for his character Father Guido Sarducci. Novello was born in Ashtabula, Ohio, on January 1, 1943, but lived in Lorain for most of his childhood and graduated from Lorain High School in 1961. After publishing *The Lazlo Letters*, a collection of humorous letters to celebrities and public officials, in 1977, Novello was hired as a writer for *Saturday Night Live*.

His famous character debuted on *Saturday Night Live* in 1978 and became one of the show's most beloved characters. According to Novello, Father Sarducci was inspired by Novello's year spent living in Rome. He said in an interview with the *San Francisco Chronicle* that a "priest character had authority, so people sort of paid attention and I could talk about politics from a unique point of view." Novello played this character on *Saturday Night Live* for several years in the 1970s and 1980s. The character was later chosen by *Rolling Stone* as one of the forty best *Saturday Night Live* characters of all time. Father Sarducci appeared on various other television shows, such as *Married with Children*, *Unhappily Ever After* and *The Colbert Report*. Novello also appeared in the movies *Gilda Live!*, *Casper* and Disney's *Atlantis: The Lost Empire*, and he published additional comedy books.

Mark Nesbitt

Historical writer Mark Nesbitt was born in Lorain in 1949 and graduated from Lorain High School in 1967. After graduating from Baldwin College in 1971, he worked in Gettysburg, Pennsylvania, as a National Park Service Ranger and historian. But Nesbitt always knew that he wanted to be a writer, so after five years with the National Park Service, he started his own research and writing company called Interpretive Enterprises. His first published work was a children's book called *The Little Drummer Boy*. He then turned his attention to the history of Gettysburg, publishing *If the South Won Gettysburg* in 1980.

Nesbitt's next project was a book on the ghost stories of Gettysburg, which he had been collecting since he first started working as a park ranger. *Ghosts of Gettysburg: Spirits, Apparitions and Haunted Places of the Battlefield* was published in 1991 to significant success. The book became a series, and many of Nesbitt's stories have been featured on the History Channel, the Discovery Channel, A&E, Unsolved Mysteries and more.

The Ghosts of Gettysburg series also received the National Paranormal Awards for "Best True Hauntings Collection" and "Best 'Local Haunt' Guidebook." Nesbitt also founded the Ghosts of Gettysburg Candlelight Walking Tours.

Bruce Weigl

He calls himself a teacher who writes;
a soldier who fought and a veteran who cares.
—Morning Journal

In 2013, Bruce Weigl—who was born and raised in Lorain—was one of the top three finalists for the Pulitzer Prize in poetry for his book *The Abundance of Nothing*. This book (his thirteenth book of poems) contains poetry that shares Weigl's experiences during the Vietnam War and merges the memories of his experiences as an eighteen-year-old fighting in a war with his Buddhist perspectives of today.

The Pulitzer jury said this about his book: "a powerful collection of poems that explore the trauma of the Vietnam War and the feelings that have never left many of those who fought in the conflict." Weigl has returned to Vietnam more than a dozen times, including times in which he has helped Vietnamese poets to translate their work. During one of his visits, he met a well-known Vietnamese poet; as they conversed, they discovered that they had fought against each other, and now both write about peace. Fittingly, *The Abundance of Nothing* is dedicated to this Vietnamese poet friend.

Shortly after his nomination was announced, he was quoted in the *Morning Journal* as saying, "This book is more about my willingness to allow my Buddhist training into my work for the first time. What happens is you live a certain life, and at the heart of Buddhism is a prayer with a very simple idea, that the greatest joy in the world comes from making other people happy."

In his memoir, *The Circle of Hanh*, published in 2000, he muses, "The paradox of my life as a writer is that the war ruined my life and in return gave me my voice."

This was his second nomination for the Pulitzer; he was nominated in 1988 as well for his book *Song of Napalm*. He has also won numerous other writing awards, including two prestigious Pushcart Prizes, the Robert Creeley Award,

Bruce Weigl. *Courtesy of Kel Arroyo.*

the Lannan Literary Award for Poetry, the Poet's Prize from the Academy of American Poets, the Paterson Poetry Prize and the Cleveland Arts Prize. He has received a fellowship from the National Endowment for the Arts and from the Yaddo Foundation and has published material in the *New York Times*, the *Paris Review* and the *New Yorker*.

Weigl was born in Lorain on January 27, 1949, and he grew up in the part of the city known as South Lorain. His father worked in the steel mill; Weigl's upbringing, like that of so many others in Lorain, was working class, with his grandparents being Eastern European immigrants. Weigl has said there weren't many books in his home. Success was defined in the blue collar–class culture in South Lorain, he shares, with high school graduation and the ability to get a job. When he was in the sixth grade or so, though, despite the lack of literary influences in his life, he began writing stories. To encourage him, someone purchased a manual typewriter for him.

He graduated from Lorain Admiral King High School in 1967 and began serving in the Vietnam War in December in the First Air Cavalry. He enlisted after being told about college financial aid opportunities for veterans by a recruiter. After being awarded the Bronze Star, he returned to Lorain and began taking classes at Lorain County Community College through the GI Bill. He continued his education, earning a bachelor's degree at Oberlin College, then a master of arts degree in creative writing at the University of New Hampshire and a PhD in literature at the University of Utah.

He has taught English and creative writing, teaching at Penn State, the University of Arkansas and Old Dominion University before returning to Lorain County. In 1998, he began teaching at Lorain County Community College (LCCC), where he became a distinguished professor. At LCCC, he started an online literary journal, *North Coast Review*. In the fall of 2014, he became the faculty liaison for veterans' services. When he retired from teaching in 2017, he continued his work with veterans at the college.

For more than twenty years, he has also participated in an annual two-week writing workshop at the Joiner Institute in Boston, Massachusetts. There, he has helped veterans find their voices, so they can process their war experiences. Weigl has published numerous collections of critical essays, and has also published Romanian poetry translations and edited multiple poetry anthologies. His own work also appears widely in anthologies.

A Note About Sherwood Anderson

Lorain County is blessed with multiple townships with smaller populations, ones that are nevertheless rich in history. Camden Township is a perfect example, with a population of 2,046 in 2010. Its most famous son is novelist and author Sherwood Anderson, born there on September 13, 1876; his most famous book is *Winesburg, Ohio*. This novel described Anderson's youth in Clyde, Ohio, in nearby Sandusky County. He fought in the Spanish-American War and then attended Wittenberg College in Ohio for one year before ultimately leaving for Chicago to work as a writer of advertisements. He briefly came back to Lorain County in the early part of the twentieth century, serving as the president of the Anderson Manufacturing Company in Elyria. Although his work is somewhat forgotten today, it was his influence that helped Ernest Hemingway's and William Faulkner's first novels to be published—and he also influenced the work of John Steinbeck.

LITTLE-KNOWN OBERLIN HISTORY

Oberlin was founded in 1833 by John Jay Shipherd, a Presbyterian minister, and Philo Stewart, who also became a Presbyterian minister. They named the new settlement after Reverend John Frederick Oberlin, a French clergyman they admired. The two founders met in nearby Elyria, where they discovered a mutual concern: a lack of Christian principles among people settling in the area.

The college was also established in 1833 (called the Oberlin Collegiate Institute until 1850) and quickly gained support of Charles Grandison Finney, a well-respected, fiery Presbyterian minister who earned the nickname of the Father of Modern Revivalism.

Finney's reputation was so high that more students began coming to the college than settlers to the town. In the early days, there was no cost to attend the college.

In 1835, many former Lane Theological Seminary students began studying at Oberlin Collegiate Institute; because of the beliefs of these men, the college became known for its abolitionist leanings. Pamphlets advertised that all youth were welcome as members, regardless of color. In 1837, four women began studying the full collegiate course, with Mary Caroline Rudd, Mary Hosford and Elizabeth Prall finishing the program in 1841; Mary Fletcher Kellogg also attended but did not finish with the other three women.

Lucy Stanton Day Sessions, an educator and abolitionist, is considered by some to be the first African American woman to complete a four-year college course, earning a certificate from the ladies' literary course from

Oberlin College in 1850. She was born in Cleveland, Ohio, on October 16, 1831, to Samuel, a free-born black barber, and Margaret. Her father died when she was two years old, and her mother later married a man named John Brown, a black businessman who helped fugitives on the Underground Railroad and who created Cleveland's first public school for black people.

Lucy Stanton enrolled in Oberlin Collegiate Institute in 1846, and in 1849, she became the president of the school's Ladies Literary Society. She therefore gave a commencement speech, which was an appeal to end slavery. After graduating, she moved to Columbus to work as the principal of a school and, in 1852, returned to Cleveland. She married William Howard Day, a man she met in Oberlin. Day worked as a librarian and edited a newspaper focusing on abolitionism, the *Alienated American*. In 1854, Lucy had a short story published in the newspaper, one of the first African Americans to publish fiction in the United States.

In 1856, they moved to Canada to teach former slaves who had fled the country, and she gave birth to a daughter, Florence. The following year, Day left for England for business but also requested a divorce, causing Lucy to return to Cleveland, where she worked as a seamstress and continued to fight for abolitionism. In 1866, the Cleveland Freedman's Association helped her to teach in Georgia and Mississippi; in the latter state, she met and married Levi Sessions in 1878. They moved to Tennessee, where Lucy became the president of the area's Woman's Christian Temperance Union. They later moved to Los Angeles, California, where she died in 1910.

Other people consider Mary Jane Patterson to be the first African American woman to earn a college degree, enrolling in the collegiate course and graduating with a BA. She was born in 1840 in Raleigh, North Carolina, possibly as a slave, although this has not been confirmed. She is thought to be the oldest of at least eight children, possibly as many as ten. When her parents, Henry Irving Patterson and Emeline Eliza Patterson, headed to Oberlin, they may have been fleeing from slavery, although that is uncertain.

Mary Jane Patterson earned her bachelor's degree, and then her siblings John, Emma and Chanie Ann followed suit. All four became teachers. Patterson taught at the Institute for Colored Youth in Philadelphia and then the Preparatory High School for Colored Youths in Washington, D.C. In 1871, she served as the first black principal of the Preparatory High School for Negroes and continued to work until she died on September 24, 1894.

Because Oberlin is so well known for its participation in the Underground Railroad, most of the stories in this chapter will focus on lesser known elements of its history—but here is one of the aspects of Oberlin's abolitionist

movement that needs a brighter spotlight shone upon it: the participation of two, possibly three, Oberlin men in John Brown's 1859 raid on Harpers Ferry. Yes, there is a faded monument to them in Martin Luther King Jr. Park at 17 East Vine Street in Oberlin, but details of these men's lives—and others connected to them—are still largely unknown. Plus, this story connects Oberlin to multiple other people of national renown.

HARPERS FERRY CONNECTION

[W]e shall meet in heaven, where we shall not be parted by the demands of the cruel and unjust monster Slavery.
—part of the letter that John Anthony Copeland wrote to his family shortly before being hanged for participating in the Harpers Ferry raid

First, some context. Fiery abolitionist John Brown planned to take a small band of followers to Harpers Ferry, Virginia, where he intended to steal munitions and then arm slaves with weapons to fuel an uprising and free the enslaved. One man who participated was named John Anthony Copeland Jr. His parents had been free black people living in North Carolina when he was born (around 1834), and in 1842, his family moved to Oberlin to escape the racism of the southern states. Copeland eventually attended Oberlin College.

He participated in the Oberlin-Wellington Slave Rescue on September 13, 1858, an event described in chapter 4, and was indicted by a federal grand jury for his actions. Charges were ultimately dropped against most participants, including Copeland. But then a relative, Lewis Sheridan Leary, recruited Copeland to become part of John Brown's Harpers Ferry raid.

Leary was born in North Carolina to free parents of mixed heritage, the second of five children. His father was named Matthew, and he made saddles. Matthew's father was Jeremiah O'Leary, descended from Irish immigrants. There are conflicting reports about the race of his mother, Julia A. Menriel Leary, but she did come from mixed heritage.

When Leary turned twenty-one in 1856, he moved to Oberlin and found work making horse harnesses. Two years later, he married Mary Sampson Patterson; they had one child, a daughter named Lois. He joined the Oberlin Anti-Slavery Society and also participated in the Oberlin-Wellington Slave Rescue. He, too, was indicted, but had charges dropped.

Then there is Shields Green, the third man recruited by Brown in Oberlin (although there isn't evidence that he actually lived there). He was born around 1836 in South Carolina as a slave. It is not known how he gained freedom, but after he did, he became friends with the famous abolitionist Frederick Douglass. It is believed that Douglass introduced him to Brown. Despite the uncertainty of where Green lived, Oberlin honors his memory along with the other two men.

Harpers Ferry Raid

On October 16, 1859, twenty-one men (including Brown, Copeland, Leary and Green) arrived at their destination in Virginia. They captured the arsenal, as planned, but became trapped inside the building. Copeland attempted to flee and was captured. Two days later, a group of U.S. Marines entered the arsenal and captured seven more men, including Brown. This became known as the Harpers Ferry Raid.

Brown, Copeland and the others were charged with treason and sentenced to death. Brown was hanged on December 2 and Copeland on December 16. Copeland's body was taken by students at the Winchester Medical College, and his family never received any of his remains.

When Leary tried to escape from the soldiers who had surrounded them, he was shot and died the next day. It is not known what happened to his body. His widow later married Charles Henry Langston, and they left for Kansas. They had a daughter named Caroline Mercer Langston. She, in turn, married James Hughes and gave birth to a son, the Harlem Renaissance poet of renown Langston Hughes.

On October 16, 1859, John Brown led a small band of men to take over the Harpers Ferry arsenal, including three men from Oberlin. The goal was to arm slaves for a rebellion. *Library of Congress.*

Green participated in the Harpers Ferry raid and was hanged on December 16 for his actions. Just like with Copeland, his family never received any of his remains.

After the executions, Oberlin College professor James Monroe, who later served as a U.S. consul to Brazil and was elected five times to serve as a congressman, was approached by Copeland's family. They wanted his assistance in attempting to retrieve Copeland's body.

Monroe was an ardent abolitionist, believed that African Americans should be allowed to vote and was a friend of Frederick Douglass. He knew how dangerous it was—especially after the politically charged raid—for a person with his beliefs to travel to southern states. But he nevertheless did so in December 1859, identifying himself in Virginia as being from Russia. That's because Oberlin was far too well known for its abolitionist actions, especially after the Oberlin-Wellington Slave Rescue received national attention. (This rescue even ignited the fury of President James Buchanan.) Since Oberlin was in Russia Township, Monroe's dissembling was at least fairly close to the truth. Monroe was too late to be of assistance, with Copeland's body already having been taken, an "offense for which their school was reportedly burned down by Union soldiers during the Civil War." Oberlin residents held a memorial service for Copeland and the other Oberlinites who died in the raid. The service was held at the First Church of Oberlin, and they also erected a monument in the men's honor.

Monroe later lived in an 1866 home originally built for General Giles W. Shurtleff, who led the first Ohio-based African American regiment in the war. This red brick Italianate home is elegant. Monroe and his wife, Julia Finney Monroe—the daughter of Charles Finney, the well-respected leader of Oberlin College—lived there for many years. This home is now part of the Oberlin Heritage Center, open for tours that focus on abolition and the Underground Railroad, among other topics. The address is 73½ South Professor Street.

A monument exists of Shurtleff at 159 South Professor Street, in front of the third of his three homes he had built in Oberlin. The structure is now a bed and breakfast. Shurtleff was an 1859 graduate of Oberlin College and an outspoken abolitionist. While leading the Monroe Rifles in the Union army (a unit named after Oberlin's James Monroe), he was captured by the Confederates in Virginia in August 1861. He then spent a year in a Confederate prison.

Above: First Church of Oberlin was a meeting spot for abolitionists in the pre–Civil War era. A plaque honoring Reverend Antoinette Brown Blackwell, the first female minister in modern times, is in its front lawn. *Tracy Isenberg.*

Right: This statue in Oberlin honors General Giles W. Shurtleff, the Civil War hero who led the Fifth U.S. Colored Troops. Shurtleff is buried in nearby Westwood Cemetery. *Tracy Isenberg.*

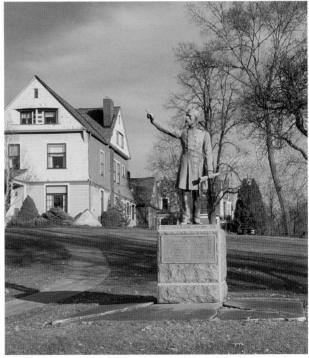

First Church of Oberlin UCC is still an active church, located at the intersection of S.R. 58 and 511. During one of his visits to Oberlin, Martin Luther King Jr. gave two passionate talks at the church.

As for Shurtleff himself, after being released in a prison exchange, he declined to take a medical discharge, instead commanding the black fighting unit organized by John Mercer Langston, whose fascinating life was described in chapter 1. Although Shurtleff was badly wounded in battle, he survived the war, returning home to teach Latin at Oberlin College and do fundraising for the institution.

ANTOINETTE LOUISA BROWN BLACKWELL

The Reverend Antoinette Brown Blackwell is said to be the first female clergy ordained in modern times in a mainstream denomination, ordained by the Congregational Church in 1853.

Born on May 20, 1825, in Henrietta, New York, her father was Joseph Brown, a farmer and justice of the peace, her mother, Abigail Morse. She, like her siblings, began attending school at age three. She heard evangelist Charles Grandison Finney preach as a child in Rochester, New York, during the Second Great Awakening, a Protestant religious revival of significance, and joined the Congregational Church by age eight. Her family supported antislavery and temperance movements, along with general moral reform.

Brown was a student of the Monroe Academy and became a teacher in 1841. She desperately wanted to attend Oberlin College, a school known for its commitment to equally educating women, as well as African Americans, and its evangelical theology. She began attending in 1846 and also began a lifelong friendship with noted abolitionist and women's rights advocate Lucy Stone. Stone attended Oberlin College, graduating in 1847 and supporting herself by teaching and doing housework in the women's boarding hall for three cents per hour.

Female students at the college at the time were required to attend male students' debates but could not participate. So, Brown and Stone organized a female debate event at the college, both wanting practice in public speaking: Brown for her preaching, Stone for her lecturing. Liberal as the college was, though, they had "misgivings" about a debate by women. According to *Standard History of Lorain County Ohio*, their debate "proved an unusually brilliant one, but the faculty decided that it was contrary to St. Paul for

Antoinette Brown Blackwell earned a literary degree from Oberlin College in 1847 and is considered the first female minister in modern times in a mainline church. *Tracy Isenberg.*

women to speak, and that it must not happen again. An old colored woman who owned a small house, and whom Lucy Stone had taught to read, consented to let them meet in her parlor." In the summer, they sometimes met outdoors, secluded in the woods.

Brown earned a literary degree from Oberlin College in 1847 and then was considered a resident graduate for the next three years. While she was training for ministry, she was not permitted to enroll in the college's theology department. And although many disapproved of women speaking in public forums, she began speaking in Ohio and New York on antislavery and women's rights topics. At the 1850 commencement, the college did not award her a theology degree.

She planned to return to New York to raise funds for people in poverty. But after she attended the first National Women's Rights Convention in Massachusetts, her New York supervisors were not as interested in working with her, so she began lecturing independently in Ohio, Pennsylvania and New England states. Topics were controversial: women's rights, temperance and antislavery. She sometimes preached on Sundays.

Brown was asked to serve as minister for the South Butler, New York Congregational church in the fall of 1852. She accepted the offer, rather than one made by Horace Greeley and Charles H. Dana; these men offered to provide her support if she chose to preach in New York City. Blackwell was ordained on September 15, 1853.

Accepting this call didn't stop her from participating in reform-based conventions. In 1853, she spoke at the World's Temperance Convention, but attendees were so horrified at a woman on the platform that they shouted until she left. In July 1854, amid increasing doubts about her faith, she resigned from the church she pastored.

She took a few months off from work before returning to New York City. There, she began writing for Greeley's *New York Tribune* and provided support for female criminals and prisoners along with Abby Hooper Gibbons. She met another reformer, Samuel Charles Blackwell, at this time, and they married in 1856.

Many members of the Blackwell family were involved in reform movements, and Antoinette Blackwell and her new husband moved wherever they went, including Cincinnati, back to New York and to New Jersey. Over the first thirteen years of her marriage, she gave birth to seven children, with five daughters living to adulthood.

In 1860, she became involved in another controversy, this one about divorce. Unlike Susan B. Anthony and Elizabeth Cady Stanton, she did not believe in divorce and debated that issue with them. Blackwell said that "the married partner can not annul his obligations towards the other, while both live….All divorce is naturally and morally impossible, even though we should succeed in annulling all legalities."

During the Civil War, she worked with the two women to form the Women's National Loyal League, an organization that supported both emancipation and the right to vote for black men and women. In 1869, she and other suffragists disagreed again. Antoinette Blackwell and Lucy Stone supported the passage of the Fourteenth Amendment, which would give the right to vote to all men, regardless of color. Anthony and Stanton's group, the National Woman Suffrage Association, opposed the amendment because women weren't included. Overall, though, Blackwell maintained good relationships with these women.

That same year, she published her first book, titled *Studies in General Science*. Topics covered included reconciling the natural world with revealed religious, the unity of the physical and mental universe and how mind and matter are related. She was influenced by Herbert Spencer and Charles

Darwin. Future books of hers included *The Sexes throughout Nature* (1875), which argues that equality of the sexes is necessary as part of evolution. The following year, she published *The Physical Basis of Immortality*, which explored the timelessness of souls; in 1893, *The Philosophy of Individuality*; in 1914, *The Making of the Universe*; and in 1915, *The Social Side of Mind and Action*. She also published a novel in 1871, *The Island Neighbors*, and a book of poetry, *Sea Drift*, in 1902.

Blackwell also helped to create the Association for the Advancement of Women in 1873 and was a regular participant of American Association for the Advancement of Science meetings. She served as president of the New Jersey Suffrage Association in 1891 and helped to found the American Purity Association that same year. This association was against state regulation of prostitution, as well as reforming social relationship between the sexes.

Later in life, Blackwell mostly lived in New Jersey, with small amounts of time in New York, occasionally traveling to lecture elsewhere. Blackwell lived long enough to vote in the 1920 presidential election, choosing the Republican candidate, Warren G. Harding. She was the only woman who attended the Women's Rights Convention of 1850 to live long enough to do so.

Although she actively pastored a Congregational church for a very short time, she also received recognition from the American Unitarian Association in 1878. She sought a pulpit but didn't find one. That year, she received an honorary degree from Oberlin College as well, in recognition of her theological studies. In 1908, the college presented her with an honorary DD. While living in New Jersey, she provided land for a Unitarian house of worship in the town of Elizabeth, and in 1908, the Elizabeth Society considered her a minister emeritus of All Souls Church.

Blackwell died on November 21, 1921, at the age of eighty-six in Elizabeth, New Jersey. On November 9, 2014, the First Church in Oberlin UCC and the United Church of Christ held a ceremony in which they unveiled a historical marker honoring her life. The marker is located on the front lawn of the First Church in Oberlin UCC at the intersections of Route 58 and Route 511.

MOSES FLEETWOOD WALKER

Jackie Robinson became one of baseball's most famous players for supposedly breaking the color barrier of Major League Baseball on April 15, 1947.

However, as groundbreaking as his actions were, Robinson was not the first black man to play Major League Baseball. That honor goes to Moses Fleetwood "Fleet" Walker, an Ohio native and Oberlin College student who broke that record in 1884, sixty-seven years before Robinson.

Walker was born on October 7, 1856, in Mount Pleasant, Ohio, the third son of Moses W. Walker and Caroline O'Harra Walker. Walker moved to Oberlin in 1877 when his father became a minister at Oberlin's Second Methodist Episcopal Church. Walker enrolled at Oberlin College in the fall of 1878 and began playing interclass baseball. Oberlin started its first varsity intercollegiate team in 1881, including Walker and his younger brother Weldy. In the final game of their first season, Oberlin won 9–2 against the University of Michigan. Michigan was so impressed by Walker and one of his teammates that it invited both players to transfer to Michigan. Both players agreed, and Walker enrolled at the University of Michigan, accompanied by Weldy and Walker's future wife, Arabella Taylor, who had also been a student at Oberlin.

Walker started his third year of college at the University of Michigan in the spring of 1882. He and Arabella married in July. In 1883, Walker left school to join the Toledo Blue Stockings baseball team. He was almost barred from joining when a representative of the Northwestern League Executive Committee motioned that no colored players be allowed in the league. The motion was eventually voted down, and Walker went on to become a professional baseball player. Throughout his baseball career, Walker faced racism from all sides—opposing teams, the press, fans and even his own teammates. At least two of his teammates with the Toledo Blue Stockings were open segregationists. Blue Stockings pitcher Tony Mullane said of Walker, "Mo[ses Walker] was the best catcher I ever worked with, but I disliked a Negro and whenever I had to pitch to him I used to pitch anything I wanted without looking at his signals."

Walker again faced trouble due to his race when the Blue Stockings played the Chicago White Stockings on August 10, 1883. The White Stockings were led by Cap Anson, a future hall-of-fame member. Anson refused to play the Blue Stockings with Walker on the field. He relented, however, after Blue Stockings manager Charlie Morton told him that forfeiting the game meant forfeiting the game receipts.

In 1884, the American Association added the Toledo Blue Stockings to its list of participating franchises. So, on May 1, 1884, the opening day of the season, Walker became the first black player to play Major League Baseball. The game was in Louisville, where Walker had been banned from playing three years

before. Walker's record was followed later in the season by his brother Weldy, who played four games for the Blue Stockings during the 1884 season.

Walker's season with the Blue Stockings was cut short due to injury. The catcher position was especially dangerous in Walker's time, as catchers typically wore little protection. Walker wore just a mask and, occasionally, a pair of slightly padded gloves. After his injury, he played only six games before being released on September 22.

After his release from the Blue Stockings, Walker never again played with a major league team. Instead, he went on to play five more seasons with several competitive minor leagues. In 1887, while Walker was playing with Newark, he again faced Cap Anson. Since the last time the two had met, Anson had written into his contract that no black players could play in an exhibition with his team. Walker was therefore forced to leave the game. Though Anson's racist attitudes were not uncommon in this era, his fame and prominence made him a large factor in baseball's growing color barrier. On the day of this particular game, the International League decided not to approve the contracts of black players going forward.

Walker's baseball career ended after he was released from Syracuse's team in 1889. He died on May 11, 1924, in Cleveland after a varied career of playing baseball, operating hotels, writing and patenting four inventions. Moses Fleetwood Walker, though largely overshadowed in history, was enormously consequential in baseball history. He was the first black man to play Major League Baseball, and reactions to his career helped to create a color barrier in the sport that lasted for decades. And while Walker had roots all over Ohio, and even outside Ohio, Oberlin gets to declare itself the starting point of his significant baseball career.

ALUMINUM

Oberlin is also the birthplace of the practical process for extracting aluminum from bauxite ore, invented by Charles Martin Hall in 1886. Before his discovery, aluminum was extremely costly to extract from ore and was considered a semiprecious metal used only for jewelry and other expensive products. Due to Hall's invention, aluminum became cheap enough to be used in everyday products such as kitchen appliances and as material for trains, aircrafts and buildings.

Hall was born on December 6, 1863, in Thompson, Ohio. He developed an interest in chemistry and invention at a young age and performed experiments in the woodshed behind his home. He set his goal of creating a process to extract aluminum while he was still in high school. In 1880, Hall enrolled in Oberlin College, where he met Professor Frank F. Jewett. Jewett had extensive experience in chemistry, with two degrees from Yale, research experience at Harvard and four years teaching at the Imperial University in Japan. He became Hall's mentor during his time at Oberlin, providing materials, advice, encouragement and access to his laboratory in Cabinet Hall.

After graduating in 1885 with a degree in chemistry, Hall continued his experiments in his home at 64 East College Street in Oberlin with Jewett's help. One major breakthrough Hall made in his experiments was the use of electrolysis. Before Hall's process, the only way to extract aluminum was by chemically reducing anhydrous aluminum chloride with sodium metal. Hall realized that electrolysis created more powerful reduction conditions than chemical methods. His next significant discovery was using melted cryolite as a solvent for aluminum oxide. In the final process, Hall extracted aluminum through electrolysis by dipping graphite-rod electrodes into a solution of aluminum oxide and melted cryolite in a graphite crucible. He successfully extracted aluminum metal from bauxite ore on February 23, 1886, only eight months after graduating from college. Both Julia, who was present at the time, and Jewett confirmed that the resulting pellets were pure aluminum.

Hall didn't stop experimenting even after he discovered his process. In his original electrolysis experiments, he had used Bunsen batteries that he and Jewett created. These batteries, though effective enough to work, were inefficient. He refined his process by performing electrolysis experiments with electricity-producing dynamos instead. His next step was to patent and capitalize on his invention, but he had a rocky start in these endeavors. When he applied for a patent for his extraction process, he learned that there was a parallel discovery of the process by Frenchman Paul Héroult. To recognize the parallel discovery, the aluminum extraction process is now known as the Hall-Héroult process. Hall then began developing his discovery with Cowles Electric Smelting and Aluminum Company in Cleveland, but the owners eventually dropped the project.

After many failed attempts, Hall found support from financier Captain Alfred Hunt. In 1888, the two founded the Pittsburgh Reduction Company, which later became the Aluminum Company of America (ALCOA).

ALCOA opened endless possibilities for aluminum. By 1914, the metal that had once cost as much as silver only cost eighteen cents per pound. Hall's process made aluminum a viable material to use in a range of consumer products. It also allows aluminum to be used in long-distance electrical lines, making electricity a commonplace and inexpensive part of modern life.

Hall's discovery made him a fortune, but he did not become a miser with his money. He used much of his wealth to give back to his alma mater and the Oberlin community, supporting education, art, religion and conservation. His gifts to Oberlin College include his collection of Eastern art, funds for the Sophronia Brooks Hall auditorium, property to build the Hall Arboretum and funds for an organ designed by E.M. Skinner for Finney Chapel. He was also a member of Oberlin's Board of Trustees from 1905 until his death in 1914. Upon his death, he left $5 million to Oberlin College.

Hall died on December 27, 1914, three years after being awarded the prestigious Perkins medal for his contribution to science and commerce. Today, Lorain County residents can drive by the Hall family home at 64 East College Street in Oberlin to see where Hall made his world-changing discovery. The building is now owned by Oberlin College and is not open to the public. The home of Professor Jewett on 73 South Professor Street, however, is open for guided tours by the Oberlin Heritage Center. His home is recognized by the American Chemical Society as a National Historic Chemical Landmark.

BIBLIOGRAPHY

African American Registry. "John M. Langston, America's First Elected Black Politician." November 19, 2017. https://aaregistry.org/story/john-m-langston-americas-first-elected-black-politican.

American National Biography Online. "Antoinette Louisa Brown Blackwell." Accessed November 19, 2017. http://www.anb.org/view/10.1093/anb/9780198606697.001.0001/anb-9780198606697-e-1500064.

Avery, Elroy McKendree. *A History of Cleveland and Its Environs: The Heart of New Connecticut.* Chicago and New York: Lewis Publishing Company, 1918.

Beers, J.H. *Commemorative Biographical Record of the Counties of Huron and Lorain, Ohio: Containing Biographical Sketches of Prominent and Representative Citizens, and of Many of the Early Settled Families.* N.p.: J.H. Beers and Co., 1894.

Bibb, Leon. "Lorain County Community College Professor Bruce Weigl Was Finalist for Pulitzer Prize for Poetry." *News 5 Cleveland,* May 17, 2013. https://www.news5cleveland.com/news/local-news/my-ohio/lorain-county-community-college-professor-bruce-weigl-was-finalist-for-pulitzer-prize-for-poetry.

———. "My Ohio: Volunteers at Old Cemetery Honor Those Buried There, Although Few Tombstones Mark Graves." *News 5 Cleveland,* November 15, 2013. https://www.news5cleveland.com/news/local-news/my-ohio/volunteers-at-old-cemetery-honor-those-buried-there-although-few-tombstones-mark-graves.

Biographical Directory of the United States Congress. "Edwards, Pierpont, (1750–1826)." Accessed November 18, 2017. http://bioguide.congress. gov/scripts/biodisplay.pl?index=E000079

———. "Perkins, Bishop Walden, (1841–1894)." Accessed November 19, 2017. http://bioguide.congress.gov/scripts/biodisplay.pl?index=P000228

———. "Townshend, Norton Strange (1815-1895)." Accessed November 18, 2017. http://bioguide.congress.gov/scripts/biodisplay.pl?index=T000338.

Biography. "John Mercer Langston," Accessed November 18, 2017. https:// www.biography.com/people/john-mercer-langston-9373265.

———. "Toni Morrison." Accessed November 18, 2017. https://www. biography.com/people/toni-morrison-9415590.

Black Past. "John Anthony Copeland, Jr. (1836–1859)." Accessed November 19, 2017. http://www.blackpast.org/aah/copeland-john-anthony-jr-1836-1859.

———. "Leary, Sherrard Lewis (1835–1859)." Accessed November 19, 2017. http://www.blackpast.org/aaw/leary-sherrard-lewis-1835-1859

———. "Shields Green (c. 1830–1859)." Accessed November 19, 2017. http://www.blackpast.org/aah/green-shields-c-1830-1859.

Blevins, Rich. *Ed McKean: Slugging Shortstop of the Cleveland Spiders*. Jefferson, NC: McFarland. 2014.

Blodgett, Geoffrey. *Oberlin Architecture, College and Town: A Guide to Its Social History*. Kent, OH: Kent State University Press. 1985.

Bonisteel, R.O. *John Monteith: First President of the University of Michigan*. Ann Arbor: University of Michigan Press, 1967.

Brady, Dan. "Kipton's Civil War Monument," *Brady's Lorain County Nostalgia*, June 24, 2011. http://danielebrady.blogspot.com/2011/06/kiptons-civil-war-monument.html.

———. "Meet Pvt. Cornelius Quinn," Parts 1-5," *Brady's Lorain County Nostalgia*. Accessed November 19, 2017. http://danielebrady.blogspot. com/search?q=Cornelius+Quinn.

———. "Peter J. Miller House Then and Now," *Brady's Lorain County Nostalgia*, April 5, 2011. http://danielebrady.blogspot.com/2011/04/peter-j-miller-house-then-and-now.html.

Bragg, Marsha Lynn. "Toni Morrison Dedicates a Bench by the Road," *Oberlin Alumni Magazine* 104, no. 4 (Summer 2009). http://www2.oberlin. edu/alummag/summer2009/ats.html.

Brownhelm Historical Association. "Col. (Judge) Henry Brown." Accessed November 18, 2017. http://www.brownhelmhistory.org/col-henry-brown.

———. "Early Brownhelm History." Accessed November 18, 2017. http://www.brownhelmhistory.org/early-brownhelm-history.

Bryant & Stratton College. "History of Bryant & Stratton College." Accessed November 18, 2017. https://www.bryantstratton.edu/about-us/history.

Buhle, Paul, and Mari Jo Buhle, eds. *The Concise History of Woman Suffrage.* Champaign: University of Illinois Press. 2005.

Buswell, Dorothy McKee. "The Grass Roots of Democracy," LaGrange Township. Accessed November 19, 2017. http://www.lagrangetownshipohio.net/township-history.html.

Cayton, Andrew R.L., Richard Sisson, and Chris Zacher. *The American Midwest: An Interpretive Encyclopedia.* Bloomington: Indiana University Press, 2007.

Chronicle Telegram. "Family Uncovers Forgotten Cemetery." November 20, 2007. http://www.chroniclet.com/news/2007/11/20/Family-uncovers-forgotten-cemetery.html.

City of Amherst. "Amherst at a Glance." Accessed November 19, 2017. http://www.amherstohio.org/index.php?site=amherst&ContentType=article&articlenum=26&menuitemid=140

Cleveland Museum of Natural History. "Fierce Prehistoric Predator." Accessed December 7, 2017. https://www.cmnh.org/dunk.

Columbia Historical Society. "Columbia Township Cemetery." Accessed November 19, 2017. https://www.columbiatwp.us/cemetery.html.

———. "Columbia Township History." Accessed November 19, 2017. https://columbiatwp.us/about.html.

———. "Harry Bastard of Devonshire, England." Accessed November 19, 2017. https://columbiatwp.us/forms/HBastard.pdf.

Czup, Terri. "Avon's First Settler, Wilbur Cahoon." Cleveland.com, July 31, 2014. https://www.cleveland.com/avon/index.ssf/2014/07/avons_first_settler_wilbur_cah.html.

Delozier, Jonathan. "Cheese Fest Ending After This Summer, Could Be Re-branded in Future," *Wellington*

Dubelko, Jim. "Levi Scofield House." *Cleveland Historical.* Last modified October 13, 2017. https://clevelandhistorical.org/items/show/742.

Elyria Rotary Club. "Care of the Crippled Child." Disability History Museum. Accessed November 19, 2017. http://www.disabilitymuseum.org/dhm/lib/catcard.html?id=952.

Encyclopedia Britannica. "Charles Martin Hall," Accessed November 19, 2017. https://www.britannica.com/biography/Charles-Martin-Hall.

———. "Toni Morrison," Accessed November 19, 2017. https://www.britannica.com/biography/Toni-Morrison

Encyclopedia of Cleveland History. "Willard, Archibald MacNeal." Case Western Reserve University. Accessed November 18, 2017. https://case.edu/ech/articles/w/willard-archibald-macneal/

Encyclopedia of World Biography. "Toni Morrison Biography." Accessed November 20, 2017. http://www.notablebiographies.com/Mo-Ni/Morrison-Toni.html.

Ensley, Gerald. "'Spirit of 76' Alive and Well in Port St. Joe." *US News*. Accessed November 18, 2017. https://www.usnews.com/news/best-states/ohio/articles/2017-07-08/spirit-of-76-alive-and-well-in-port-st-joe.

Enterprise, May 2, 2017. http://www.thewellingtonenterprise.com/news/7467/cheese-fest-ending-after-this-summer-could-be-re-branded-in-future.

Federal Judicial Center. "Edwards, Pierpont." Accessed November 18, 2017. https://www.fjc.gov/history/judges/edwards-pierpont

Fem Bio. "Antoinette Louisa Brown Blackwell," Accessed November 19, 2017. http://www.fembio.org/english/biography.php/woman/biography/antoinette-brown-blackwell.

Find A Grave. "Joel Terrell." Accessed November 17, 2018. https://www.findagrave.com/memorial/95408404/joel-terrell.

Firelands Historical Society. *The Firelands Pioneer*. Norwalk, OH, 1921.

Fischer, Jean. "The Cahoon File," *Avon History*. Accessed November 18, 2017. http://avonhistory.org/cah15.html.

———. "Genealogy of the Cahoon Family," Avon History. Accessed November 18, 2017. http://www.avonhistory.org/gen/cahoon.htm.

Gallatin, Jeff. "Quiet Reminders," *Pulse* (Fall 2013). http://www.pulselorainmag.com/Main/Articles/Quiet_Reminders__152.aspx.

Gorman, Ron. "Lewis Clarke: Hero in His Own Right." Oberlin Heritage Center. Accessed November 18, 2017. http://www.oberlinheritagecenter.org/blog/2013/04/lewis-clarke-hero-in-his-own-right.

Hall, Mary Beebe. *Reminiscences of Elyria, Ohio*. Lorain County Historical Society, 1900. Accessed November 19, 2017. https://archive.org/stream/reminiscencesofe00hall/reminiscencesofe00hall_djvu.txt

Heaphy, Leslie A. *The Negro Leagues: 1869–1960*. Jefferson, NC: McFarland, 2015.

Heritage Avon Lake. "Peter Miller House Museum." Accessed November 19, 2017. http://heritageavonlake.org/peter-miller-museum/index.html.

Hicok, Don. "Sesquicentennial Address." Avon History. Accessed November 17, 2018. http://www.avonhistory.org/oralhist/hicok64.htm.

Hill, Justice B. "A True Pioneer: Fleet Walker is the First African-American to Play in Major Leagues." Negro Leagues Legacy, MLB. Accessed November 19, 2017. http://mlb.mlb.com/mlb/history/mlb_negro_leagues_profile.jsp?player=walker_fleetwood

The Historical Marker Database. "Lorain County Ohio Historical Markers." Accessed November 19, 2017. https://www.hmdb.org/results.asp?County=Lorain%20County&State=Ohio.

History, Art & Archives: United States House of Representatives. "Langston, John Mercer." Accessed November 19, 2017. http://history.house.gov/People/Detail?id=16682

———. "Perkins, Bishop Walden." Accessed November 19, 2017. http://history.house.gov/People/Listing/P/PERKINS,-Bishop-Walden-(P000228).

History of Lorain County, Ohio: Illustrations & Biographical Sketches. Philadelphia: Williams Brothers, 1879.

Holsinger, M. Paul, ed. *War and American Popular Culture: A Historical Encyclopedia.* Westport, CT: Greenwood Publishing Group, 1999.

Husman, John R. "May 1, 1884: Fleet Walker's Major-League Debut." Society for American Baseball Research. Accessed November 19, 2017. https://sabr.org/gamesproj/game/may-1-1884-fleet-walker-s-major-league-debut.

James, Jessica. "Lorain's Bruce Weigl a Finalist for Pulitzer Prize in Poetry." *Morning Journal,* April 18, 2013. http://www.morningjournal.com/article/MJ/20130418/NEWS/304189977.

Jet. "Clinton Honors Noted Blacks with National Arts and Humanities Medals." January 8, 2001. https://books.google.com/books?id=67MDA AAAMBAJ&pg=PA12&lpg=PA12&dq=jet+Clinton+Honors+Noted+B lacks+with+National+Arts+and+Humanities+Medals&source=bl&ots =GtHEw1bPpZ&sig=RyrO06zzHPc0WSIhHQ32tH555pA&hl=en&sa =X&ved=0ahUKEwi62JuamY3bAhVL1oMKHeKUDeUQ6AEINzAB #v=onepage&q=jet%20Clinton%20Honors%20Noted%20Blacks%20 with%20National%20Arts%20and%20Humanities%20Medals&f=false

Jindra, Robin Zavodsky. *Westwood: A Historical and Interpretive View of Oberlin's Cemetery.* Oberlin: Ohio Historical and Improvement Organization, 1997.

Krohn, B. "Oberlin Anti-Slave Rebellion Preceded Raid at Harpers Ferry," *Plain Dealer,* August 8, 2009. https://www.cleveland.com/travel/index.ssf/2009/08/post_7.html.

Liberator. "The Eloquent Speech of Langston." Oberlin College of Conservatory, June 3, 1859. Accessed November 19, 2017. http://www2.

oberlin.edu/external/EOG/Oberlin-Wellington_Rescue/Liberator/ The%20Liberator%206-03-1859%20Eloquent%20Speech%20of%20 Charles%20Langston.htm.

Lorain County Chapter Cemeteries. Accessed November 17, 2018. http:// www.loraincoogs.org.

Lorain Historical Society. "Historic Landmarks." Accessed November 19, 2017. https://sites.google.com/site/loraincountyhistoricalsociety/landmarks.

Lorain Public Library System. "Don Novello." Accessed November 18, 2017. https://www.lorainpubliclibrary.org/research/local-research/local-authors/don-novello.

———. "History of Lorain, Ohio Chronology." Accessed November 18, 2017. https://www.lorainpubliclibrary.org/research/local-research/local-history-resources/history-of-lorain-ohio--chronology.

———. "Mark Nesbitt." Accessed November 18, 2017. https://www.lorain publiclibrary.org/research/local-research/local-authors/mark-nesbitt.

———. "Michael Dirda." Accessed November 18, 2017. https://www.lorain publiclibrary.org/research/local-research/local-authors/michael-dirda.

———. "The Underground Railroad: The Lorain County Connection." Accessed November 18, 2017. https://www.lorainpubliclibrary.org/ research/local-research/local-history-resources/underground-railroad.

Manier, Jeremy. "Next to This Fish, Sharks Are Great White Wimps." *Chicago Tribune*, November 29, 2006. http://articles.chicagotribune.com/2006-11-29/news/0611290103_1_jaws-evolutionary-niches-modern-fish.

Mayflower Families. "Lucy Bradford McRoberts." Find a Grave. Accessed November 19, 2017. https://www.findagrave.com/memorial/27920475/ lucy-mcroberts.

Murphy, Patricia. "Frank Jewett and the Jewetts: More than Aluminum." LorainCounty.com. Accessed November 19, 2017. https://www. loraincounty.com/entertainment/feature.shtml?f=25375.

Nahorn, Matthew W. "Hon. Josiah Harris." New Indian Ridge Museum. March 30, 2017.

Nesbitt, Mark. "Mark Nesbitt Biography." Smashwords. Accessed November 19, 2017. https://www.smashwords.com/profile/view/hauntgburg.

19th-Century Wellington. "Tripp's Carriage Depot." Accessed November 19, 2017. https://19thcenturywellington.wordpress.com/2013/10/06/ tripps-carriage-depot.

NOAA's National Weather Service. "Ohio's Second Deadliest Tornado Day: April 11, 1965." Accessed December 6, 2017. http://www.nws.noaa. gov/pa/fstories/2005/0405/s11apr1965a.php.

North Ridgeville History Society. "The Ridgeville History Mural," Accessed December 6, 2017. http://www.northridgevillehistoricalsociety.org/private/historymural.htm.

———. "Ridgeville's Pioneer Journeys," Accessed November 19, 2017. http://www.northridgevillehistoricalsociety.org/private/Bicenttri-foldexpanded.pdf

Oberlin College of Conservatory. "Charles Martin Hall Article." Accessed November 19, 2017. https://new.oberlin.edu/arts-and-sciences/departments/chemistry/charlesmartinhallarticle.dot.

———. "John Mercer Langston (1829–1897)." Accessed November 19, 2017. http://www2.oberlin.edu/external/EOG/OYTT-images/JMLangston.html.

———. "Memorial Arch." Accessed November 19, 2017. https://www.oberlin.edu/memorial-arch.

———. "Oberlin History," Accessed November 18. 2017. https://www.oberlin.edu/arts-and-sciences/departments/history.

Oberlin Evangelist. "The Habeas-Corpus Case—Prisoners Not Discharged." Oberlin College of Conservatory. June 8, 1959. Accessed November 19, 2017. http://www2.oberlin.edu/external/EOG/Oberlin-Wellington_Rescue/OberlinEvangelist/Oberlin%20Evangelist%201859-06-08a.htm.

Oberlin Heritage Center. "Lewis Clarke: Hero in His Own Right." Accessed November 19, 2017. http://www.oberlinheritagecenter.org/blog/2013/04/lewis-clarke-hero-in-his-own-right.

———. "The Oberlin-Wellington Rescue 1858." Accessed November 19, 2017. http://www.oberlinheritagecenter.org/cms/files/File/OB-Wellington%20Rescue.pdf.

———. "A Self-Guided Walking Tour: 'Charles Martin Hall and Oberlin's Aluminum Connection'." Accessed November 19, 2017. http://www.oberlinheritagecenter.org/cms/files/File/HallWalkingTourv2.pdf.

Ohio Channel. "Remarkable Ohio: Jay Terrell and his 'Terrible Fish'." Accessed November 19, 2017. https://www.ohiochannel.org/video/remarkable-ohio-remarkable-ohio-jay-terrell-and-his-terrible-fish.

Ohio Gravestones. "Bildad Belden." November 28, 2001. https://ohiogravestones.org/view.php?id=139306.

Ohio Historical Society. "Ohio Historic Inventory." Accessed December 6, 2017. https://www.ohiohistory.org/preserve/state-historic-preservation-office/hpsurvey/about-the-ohio-historic-inventory.

Ohio History Central. "Archibald Willard." Accessed November 18, 2017. http://www.ohiohistorycentral.org/w/Archibald_Willard.

——. "Black Laws of 1807." Accessed November 18, 2017. http://www. ohiohistorycentral.org/w/Black_Laws_of_1807.

——. "Charles Whittlesey." Accessed November 18, 2017. http://www. ohiohistorycentral.org/w/Charles_Whittlesey.

——. "Connecticut Western Reserve." Accessed November 18, 2017. http://www.ohiohistorycentral.org/w/Connecticut_Western_Reserve.

——. "Elyria, Ohio." Accessed November 18, 2017. http://www. ohiohistorycentral.org/w/Elyria,_Ohio.

——. "Folsom's Business College." Accessed November 18, 2017. http:// www.ohiohistorycentral.org/w/Folsom%27s_Business_College.

——. "Myron T. Herrick." Accessed November 19, 2017. http://www. ohiohistorycentral.org/w/Myron_T._Herrick.

——. "Oberlin Wellington Rescue Case." Accessed November 18, 2017. http://www.ohiohistorycentral.org/w/Oberlin-Wellington_Rescue_Case.

——. "Treaty of Greenville (1795)." Accessed November 18, 2017. http:// www.ohiohistorycentral.org/w/Treaty_of_Greenville_(1795)_(Transcript).

——. "Western Reserve." Accessed November 18, 2017. http://www. ohiohistorycentral.org/w/Western_Reserve.

Oklahoma Territorial Plaza. "History of Perkins." Accessed November 19, 2017. http://www.okterritory.org/history.html.

One Family Circle. "Watring Celia Launetten." Accessed December 6, 2017. http://onefamilycircle.com/getperson.php?personID=I1646&tree=Petranek_Mercer.

103rd Ohio Volunteer Infantry. Accessed November 17, 2017. http:// www.103ovi.com.

Orth, Samuel Peter. *A History of Cleveland, Ohio: Biographical.* Cleveland, OH: S.J. Clarke, 1910.

Payerchin, Richard. "Lorain Admiral Ernest J. King to be Honored by Memorial Park." *Morning Journal*, April 22, 2011. http://www. morningjournal.com/article/MJ/20110422/NEWS/304229952.

Pittsfield Township Historical Society. "Local History and Photos." Accessed November 19, 2017. http://www.pittsfieldtownshiphistoricalsociety.com.

Poetry Foundation. "Bruce Weigl." November 19, 2017. https://www. poetryfoundation.org/poets/bruce-weigl.

Poets. "Bruce Weigl." Accessed November 19, 2017. https://www.poets. org/poetsorg/poet/bruce-weigl.

Pope, Nancy. "The Great Kipton Train Wreck." Smithsonian's National Postal Museum Blog, April 22, 2013. Accessed November 19, 2017. http:// postalmuseumblog.si.edu/2013/04/the-great-kipton-train-wreck.html.

Regan, Barry. "Moses Fleetwood Walker: The Forgotten Man Who Actually Integrated Baseball." *Bleacher Report*, April 16, 2012. Accessed November 19, 2017. https://bleacherreport.com/articles/1147947-moses-fleetwood-walker-the-forgotten-man-who-actually-integrated-baseball.

Remarkable Ohio. "Lorain County." Accessed November 19, 2017. http://remarkableohio.org/index.php?/category/890.

Remington, Kaylee. "Historic Sites: Burrell Homestead Sets Stage for Sheffield Village." *Morning Journal*, April 14, 2015. http://www.news-herald.com/article/hr/20150414/NEWS/150419792.

Reynolds, Keith. "Oberlin Poet Bruce Weigl Reflects on Life and His Subject." *Morning Journal*, May 31, 2016. http://www.morningjournal.com/article/MJ/20160531/NEWS/160539927.

Ritchey, Loraine. "…And Lorain Said 'NO'!!!!…Admiral King—Lorain Ohio." *That Woman's Weblog*, December 10, 2012. Accessed November 19, 2017. https://thatwoman.wordpress.com/2012/12/10/and-lorain-said-no-admiral-king-lorain-ohio.

———. "A Cemetery Tale—Charleston Village, Lorain." *That Woman's Weblog*, January 11, 2016. Accessed November 19, 2017. https://thatwoman.wordpress.com/2016/01/11/a-cemetery-tale-charleston-village-lorain.

———. "Fleet Admiral Ernest J. King – Lake Erie's Son." *That Woman's Weblog*, May 20, 2011. Accessed November 19, 2017. https://thatwoman.wordpress.com/2011/05/20/fleet-admiral-ernest-j-king-lake-eries-son.

———. "Many Faces of the Captain Settler's Watch—Lorain 2017," *That Woman's Weblog*. July 26, 2017. Accessed November 19, 2017. https://thatwoman.wordpress.com/2017/07/26/many-faces-of-the-captain-settlers-watch-lorain-2017.

Roberson, Lisa. "Historical Marker Honors Elyria Hospital, Easter Seals Founder." *Chronicle*, September 21, 2016. http://www.chroniclet.com/Local-News/2016/09/21/Historical-marker-honors-Elyria-hospital-Easter-Seals-founder.html.

Rochester, Ohio. "Township." Accessed November 19, 2017. http://www.rochesterohio.com/township-history.html.

Rootsweb. "Randall and Allied Families." Ancestry.com. Accessed December 6, 2017. https://wc.rootsweb.ancestry.com/cgi-bin/igm.cgi?db=wrandall.

Russo, Frank. *The Cooperstown Chronicles: Baseball's Colorful Characters, Unusual Lives, and Strange Demises.* Lanham, MD: Rowman & Littlefield. 2014.

———. "Edwin John McKean." Find a Grave. Accessed November 19, 2017. https://www.findagrave.com/memorial/18977910/edwin-john-mckean.

Sagert, Kelly Boyer. "Birth of Illumination: First Hundred Years of the Lorain Public Library System." Lorain Public Library System, 2001. https://www. lorainpubliclibrary.org/about-lpls/history-of-the-library/birth-of-illumination.

Sangiacomo, Michael. "Wellington's Spirit of '76 Museum Features Archibald Willard's Famous Painting." *Plain Dealer*, December 7, 2016. https://www. cleveland.com/metro/index.ssf/2016/12/wellingtons_spirit_of_76_ museum_features_archibald_willards_famous_works_video_photos.html

Schuster-Eakin, Cynthia, "'Who Was Who in Avon' Relates History of Founding Families." *PJP Newspapers*, March 29, 2015. https://www. pjpnewspapers.com/news/who-was-who-in-avon-relates-history-of-founding-families/article_68f9bf7a-f3ae-5fb7-adf7-79d800b0170e.html

Sigsworth, Jeff. "A Brief History of North Ridgeville (Founded 1810)." Lorain Public Library System. Accessed November 18, 2017. https:// www.lorainpubliclibrary.org/research/local-research/local-history-resources/a-brief-history-of-north-ridgeville.

Smith, Christi M. "National Equal Right League (1864–1921)." *Black Past*. Accessed November 18, 2017. http://www.blackpast.org/aah/national-equal-rights-league-1864-1915

Smith, Myron J., Jr. *Tinclads in the Civil War: Union Light-Draught Gunboat Operations on Western Waters, 1862–1865* Jefferson, NC: McFarland. 2012.

Smith, Taylor J. "Historical Sketch of Avon, Ohio, to 1974." *Avon History*. Accessed November 17, 2018. http://avonhistory.org/hist/hto74.htm.

Snodgrass, Mary Ellen. *The Underground Railroad: An Encyclopedia of People, Places, and Operations: An Encyclopedia of People, Places, and Operations.* Abingdon, UK: Routledge, 2015.

Social Networks and Archival Content. "Lane, Ebenezer, 1793–1866." Accessed November 19, 2017. http://snaccooperative.org/ark:/99166/w6k64z7d.

Stack, Peter. "Don Novello Tries to Save His Sheep / One-Shot Musical Detailed in TV Special." *SF Gate*, September 2, 1997. https://www.sfgate. com/entertainment/article/Don-Novello-Tries-To-Save-His-Sheep-One-shot-2809501.php.

Stamberg, Susan. "How Andrew Carnegie Turned His Fortune into a Library Legacy." National Public Radio, August 1, 2013. https://www. npr.org/2013/08/01/207272849/how-andrew-carnegie-turned-his-fortune-into-a-library-legacy.

Stephens, Chris. "Moses Fleetwood Walker: 7 Things You Need to Know About Majors' 1st Black Player," *Bleacher Report*, April 15, 2013. https:// bleacherreport.com/articles/1604972-moses-fleetwood-walker-7-things-you-need-to-know-about-majors-1st-black-play.

The Supreme Court of Ohio and the Ohio Judicial System. "Ebenezer Lane." Accessed November 19, 2017. https://www.supremecourt.ohio.gov/SCO/formerjustices/bios/lane.asp.

Tavenner, Mary Hilaire. "Helen Steiner Rice: Woman of Talent and Courage." Lorain Public Library System. Accessed December 7, 2017. https://www.lorainpubliclibrary.org/research/local-research/local-authors/helen-steiner-rice

Theiss, Evelyn. "Former Ohio Gov. and U.S. Ambassador Myron Herrick Was Much Beloved by French." *Plain Dealer*, October 18, 2009. https://www.cleveland.com/arts/index.ssf/2009/10/former_ohio_gov_and_us_ambassa.html.

Vidika, Ron. "Lorain's Civil War. Heroes Honored 150 Years Later." *Morning Journal*, April 24, 2011. http://www.morningjournal.com/article/MJ/20110424/NEWS/304249978.

Village of Grafton. "Welcome Home to the Village of Grafton." Accessed November 19, 2017. http://www.villageofgrafton.org.

Village of Wellington. "History." Accessed November 19, 2017. https://www.villageofwellington.com/95/History.

Visit Lorain County. "History." Accessed November 19, 2017. http://www.visitloraincounty.com/business/history.

Webber, Judge A.R. *Early History of Elyria and Her People*. Salem, MA: Higginson Book Company, 1930.

Weisman, Matthew, and Paula Shorf. *General Quincy Adams Gillmore*. Lorain, OH: General Quincy Adams Gillmore Roundtable, 2016.

Willard, A.M. "A Picture that Stirred a Nation—Archibald Willard Spirit of '76." *Mentor* (July 1921). Accessed November 19, 2017, https://www.gjenvick.com/Entertainment/MotionPictures/TheMentorMotionPictures/15-APictureThatStirredANation.html.

Wright, G. Frederick, ed. *A Standard History of Lorain County Ohio: An Authentic Narrative of the Past, with Particular Attention to the Modern Era in the Commercial, Industrial, Civil and Social Development. A Chronicle of the People, with Family Lineage and Memoirs*. Chicago and New York: Lewis Publishing Company. 1916.

———. *A Standard History of Lorain County Ohio: An Authentic Narrative of the Past, with Particular Attention to the Modern Era in the Commercial, Industrial, Civil and Social Development. A Chronicle of the People, with Family Lineage and Memoirs*. Vol. 2. Chicago and New York: Lewis Publishing Company, 1916.

Wysochanski, Jon. "Anniversary Commemorated of Fatal Kipton Train Wreck that Prompted Widespread Reforms." *Chronicle*. April 21, 2016. http://www.chroniclet.com/news/2016/04/21/Anniversary-commemorated-of-fatal-Kipton-train-wreck-that-prompted-widespread-reforms.html.

INDEX

ABOUT THE AUTHOR

K elly Boyer Sagert is a full-time freelance writer living in Lorain, Ohio. She has published fourteen books, several of them historical in nature, and has been commissioned to write five historical plays. Her first play, *Freedom's Light: A Stop Along the Underground Railroad*, was a Governor's Award for the Arts nominee. She also received sole writing credits for the Emmy Award–nominated documentary *Trail Magic: The Grandma Gatewood Story*, which appeared on PBS. She is married to Don, with two grown sons: Ryan and Adam.